BLACK AMERICA SERIES

LEVY COUNTY
FLORIDA

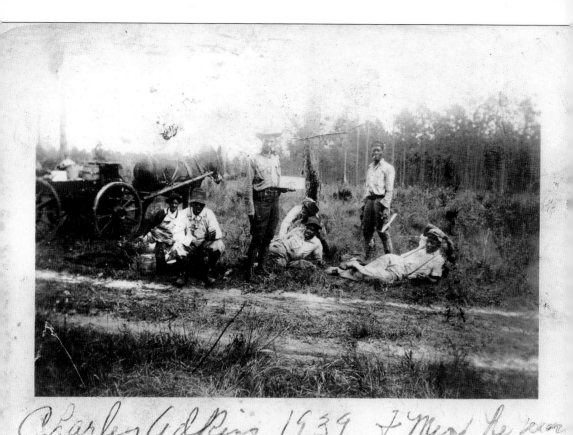

This photograph shows black men that worked for Charlie Atkins in 1939 in the turpentine woods. In the background, the mule and wagon that carried the barrels of turpentine to the still are shown.

BLACK AMERICA SERIES

LEVY COUNTY
FLORIDA

Carolyn Cohens

ARCADIA

Published by Arcadia Publishing
Charleston SC, Chicago IL, Portsmouth NH, San Francisco CA

Printed in Great Britain

Library of Congress Catalog Card Number: 2005933530

For all general information contact Arcadia Publishing at:
Telephone 843-853-2070
Fax 843-853-0044
E-mail sales@arcadiapublishing.com
For customer service and orders:
Toll-Free 1-888-313-2665

Visit us on the Internet at www.arcadiapublishing.com

CONTENTS

ACKNOWLEDGMENTS

This book is dedicated to our ancestors who toiled through struggles and worked hard; some lost their lives to leave us with an unbeatable and unforgettable legacy. Many great works and deeds will never be known because they were not recorded, but this book is an attempt to speak for some of the works of blacks in Levy County. The book is an effort to show the hard work, pride, love, and determination to survive; and this only makes one stronger. It has been more than a pleasure being welcomed into many homes, listening to stories of the past, seeing smiles, and hearing laughter that could only warm one's heart. Sometimes there was a glint of sadness, but overall one could only feel the passion and the kinsmanship of each and everyone. Looking at the photographs from the past is like taking a journey into another world and lifetime. This is true of the works of our ancestors, because a lot of the work that was done by blacks in the past is no longer needed. Modern technology has replaced manual labor.

A special word of thanks is extended to the John G. Riley Center/Museum, headquarters of the Florida African American Heritage Network, and its director, Althemese Barnes, for providing the inspiration for this book to be published. Many thanks goes to Katrina Cohens, Asia Powell, Ruth Gibbs, Juan Henley, Marjorie A. Henley, Tangela Rome, Virginia McDonald, Juanita Hunter, Mary Alice Marshall, Joe Eddie Scott, E. T. Usher, Andrew Land and Andrew Timber, Yancy Atkins, the Glover family, John Henry Donaldson, the Strong family, Lenetta Griner, Karen White, Yvonne Graham Colson, Ethel Riley, the Adams family, the U.S. Department of Agriculture, and to all the residents in Levy County.

INTRODUCTION

Levy County is most noted for its agriculture, timber, and festivals. Cedar Key is noted for its romantic atmosphere, and the small island attracts many tourists who enjoy fishing excursions and chartered boat rides. The island also has many art galleries and antique stores. Cedar Key is known for annual seafood and art festivals. In the 19th century, Cedar Key was one of the main population centers of Florida. Many slaves were brought there to build the railroad. Two brothers with the last name of Strong were slaves but were given their freedom after the railroad was complete. They settled and bought many acres of land in Otter Creek. In the late 19th century, many blacks lived in Cedar Key, but now there are no known living blacks that reside there.

Chiefland is a small town with a friendly atmosphere. Super Wal-Mart is the busiest place in town. Chiefland is also noted for its annual watermelon festival. Each year the main street is closed for the special event. Everyone looks forward to the parade, watermelon queen contest, and the watermelon-eating contest, which is the most fun.

Rosewood is noted for its tours and markers for the ones who lost their lives in the tragedy. Recently Gov. Jeb Bush visited the site to honor families of those lost.

Overall Levy County is a great place to visit and live. Driving along the Levy County highways, you can always see crops of corn, watermelons, peanuts, cantaloupes, and other vegetables. There are oak trees and pine trees as far as you can see. The cows peacefully graze in the grass, and the wildlife is plentiful. You can almost always see a baby deer beside the road, and the fishing is great too.

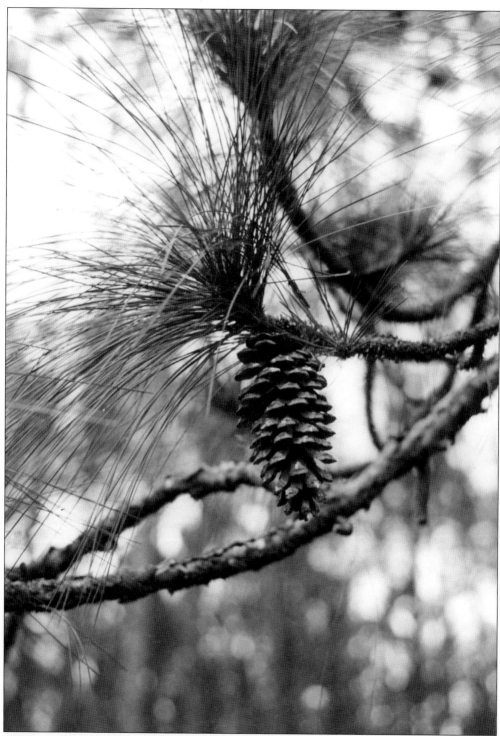

The pinecone grows on a pine tree. When it matures, it turns brown, then it produces the seeds that are planted and scattered by the wind. Pine trees have provided work for many black men in Levy County through turpentine.

One

CHIEFLAND

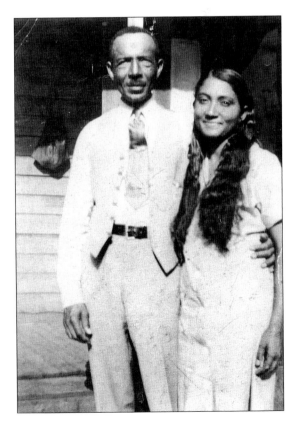

Melton and Floretta Adams lived in Adamsville, which was named after Melton Adams's father, William Bill Adams. William Adams contributed a lot to the community. Mrs. Adams belonged to the Heroines of Jericho; she was the secretary of the organization.

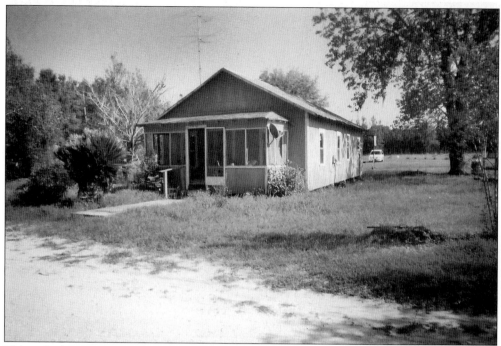

This is the home of Mr. and Mrs. Adams, located two miles outside of Chiefland. They owned many acres of land in Adamsville; the land has been passed down for four generations.

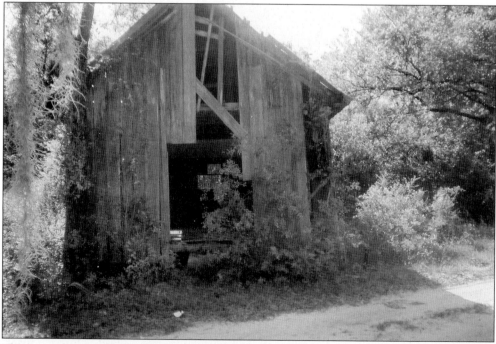

This is a picture of Adamsville's church; it is over 100 years old. The pulpit still stands. The church has wooden windows with latches. Even though the years have taken their toll, the church still holds many memories.

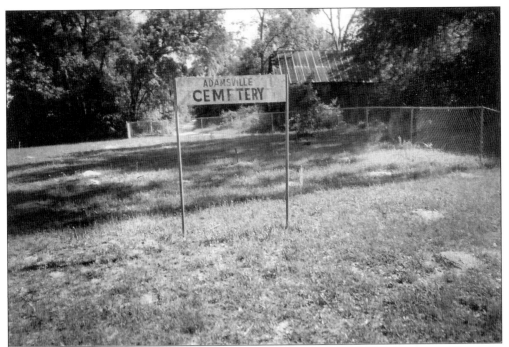

The Adamsville cemetery is very old; the older generation and their families still use the cemetery to bury their love ones. The cemetery is still being cared for by the Christian people of Adamsville.

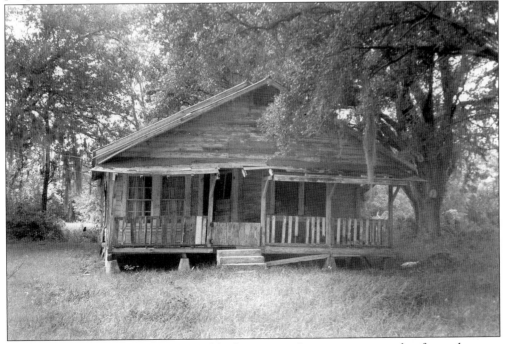

Most of the old homes occupied by blacks in Levy County were wooden frame houses. The men would get together and help build houses for each other's family. There are very few of these homes left.

John Henry Donaldson was the first black mayor of Chiefland; he served as mayor from 1989 to 1991. He began his career in city government in 1985 as a city councilman. Donaldson has been employed by Central Florida Electric Company for 29 years; he is also the minister of the West Side Church of Christ.

Deacon Andrew Lee was born in 1912; he was the former president of the local NAACP for 16 years. The NAACP honored Mr. Lee by giving an award in his name. As a teenager, he lived in Rosewood with his grandparents, Herbert and Alice Lee.

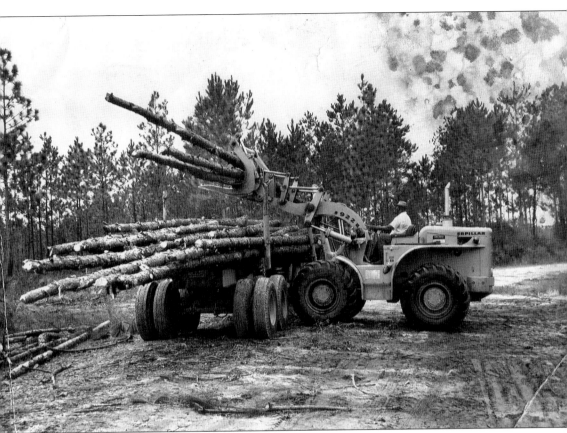

Mr. Link Mungen worked in the logging woods for Mr. E. T. Usher until he retired. Mr. Mungen was also the wishful master of St. Philips Lodge. He was also a deacon at Mount Pleasant Baptist Church in Chiefland.

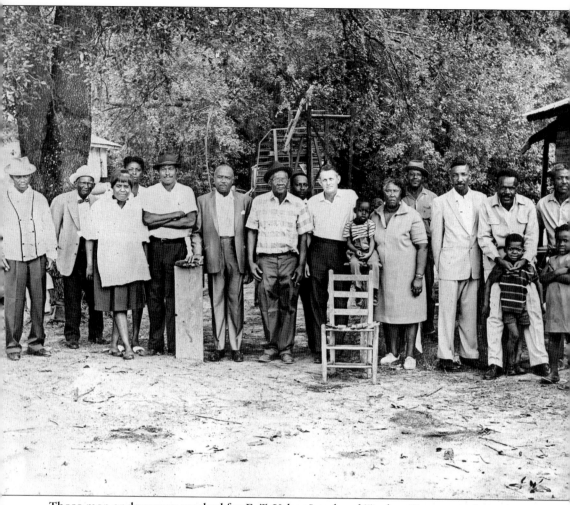

These men and woman worked for E. T. Usher Land and Timber Company; the company still exists today in Chiefland. Most of the workers shown in this photo are deceased, but there are still a few black men that work for Usher Land and Timber.

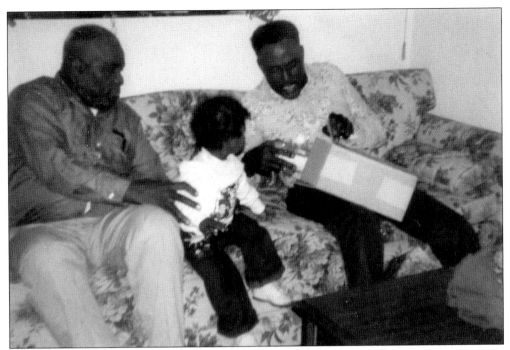

Mr. Link Mungen and Mr. Malon Blake sit on a sofa waiting to take a look at what is in the box, while the young ones watch with excitement. Both men worked for Usher Land and Timber Company.

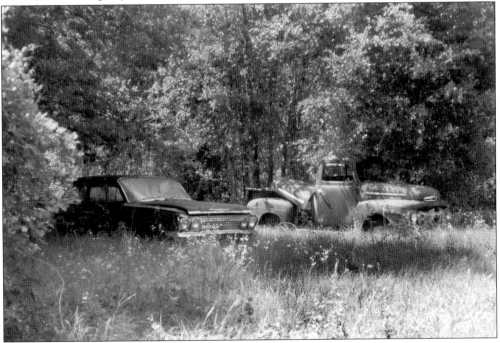

A car and a truck bring back memories for some and wishes for others. If restored, they would be priceless and beautiful. There are none of these priceless antiques to be seen except at car shows today.

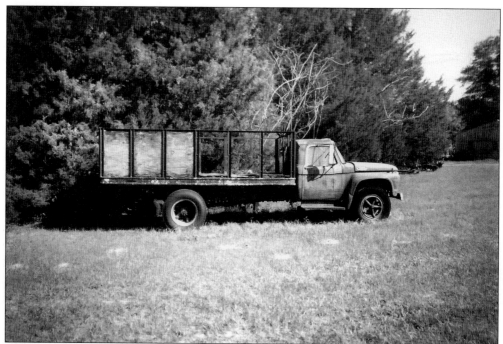

This is an old abandoned watermelon truck in Adamsville owned by Rosevelt Thompson. Hauling watermelons was hard work, but some workers had fun in the fields—not to mention it was an honest way to earn money on a daily basis.

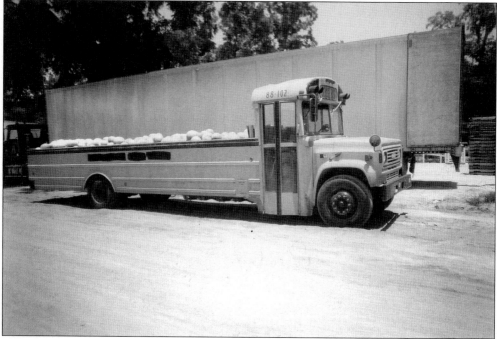

This old school bus was converted into a watermelon transport. The rescourceful people of Levy County use what they have to create what they need or want. They have ways to fix anything that is not totally destroyed.

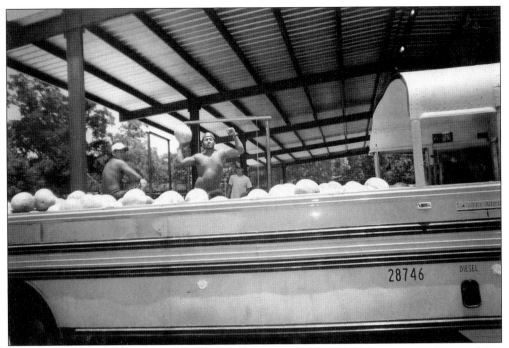

A young man shows off while unloading watermelons at the Tillis watermelon packing shed in Chiefland. The melons are brought to the shed to be transported and shipped out around the country.

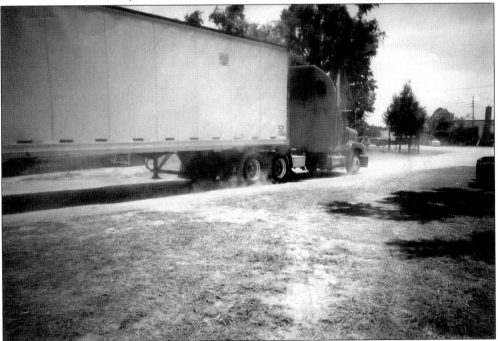

Black men driving semitrucks come from around the country to pick up watermelons to distribute them all around the world. Many black men in Levy County own their own trucks and work for themselves.

The annual watermelon festival is a big event in Chiefland. People come from many counties to see the beautiful floats, old cars, bands, and politicians. There is also a watermelon-queen contest each year.

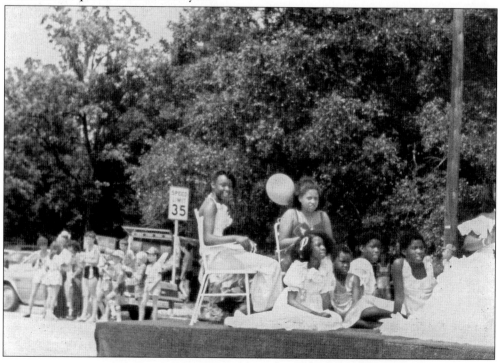

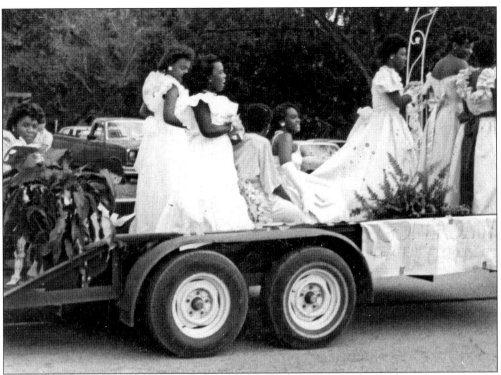

A group of young ladies smile as they ride on a float down Main Street and toss candy to the spectators in 1989. Candy tossing has since been banned from the parades.

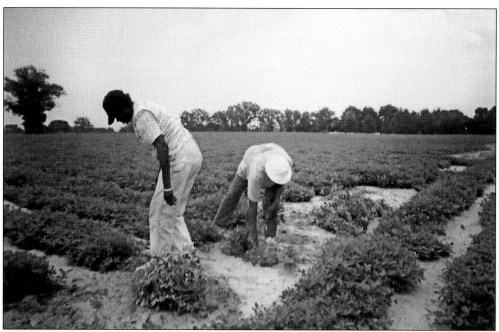

Maxine Wilcoxs and Mary Gandy pull peanuts in Chiefland. There are many different vegetables grown in Levy County. These two ladies also pick peas and other vegetables year round.

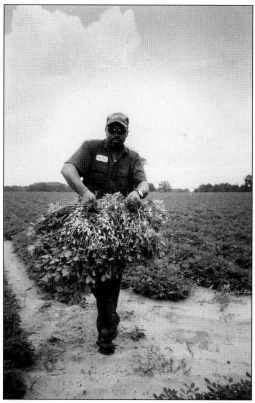

Harold Strong holds bunches of peanuts in the Matthews' field in Chiefland. Many vegetables are grown on this farm, which provides fieldwork all year round for many blacks.

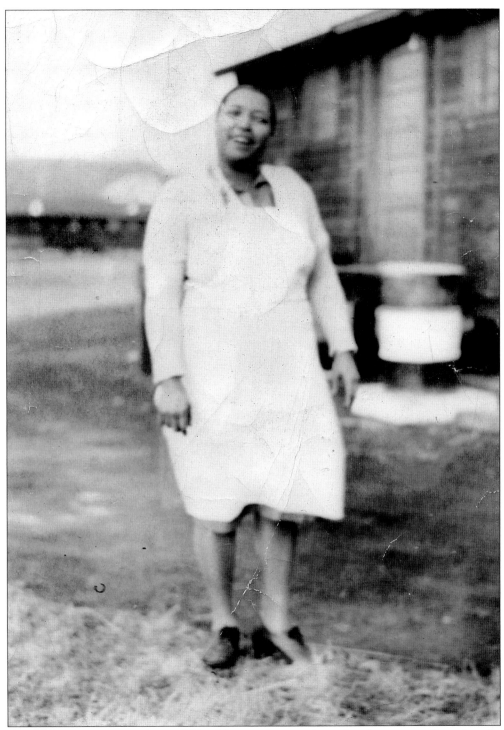

Sylvia West stands outside an old building with a rain barrel at the corner. Occasionally the water in the barrel was used for washing clothes. The barrel also kept water handy in case of fire.

Margaret J. Gibbs was known for her cooking, washing, and ironing. She worked for many wealthy white families in Chiefland. Mrs. Gibbs was born December 2, 1900. She and her husband, Amos Gibbs, were well known in the community. She was also a member of the Heroines of Jericho.

The pump was invented after the well. In some places, a small settlement only had one pump. This pump, located at the Gibbs homestead, still works. The pump, which pulls water from underground streams, is largely a thing of the past.

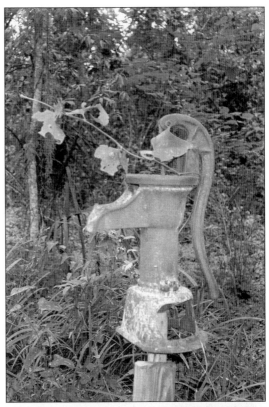

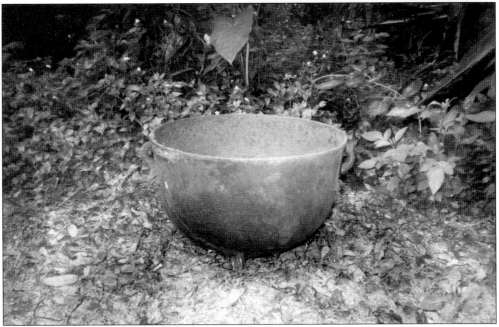

The wash pot was used to boil clothes for washing, making soap, and cooking cracklings. Pots like this are now used to cook blue crabs. This wash pot is made out of cast iron and is over 80 years old.

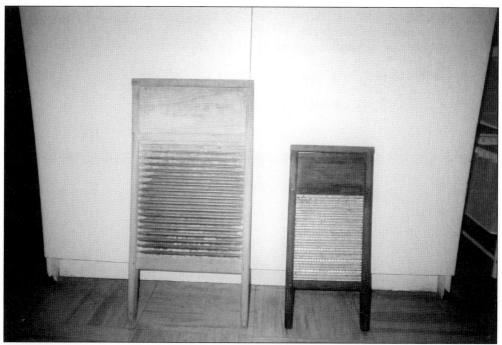

Pictured here are two rub boards; they were used before the washing machine was invented. They are not in use anymore, but these two were found at the laundromat in Chiefland.

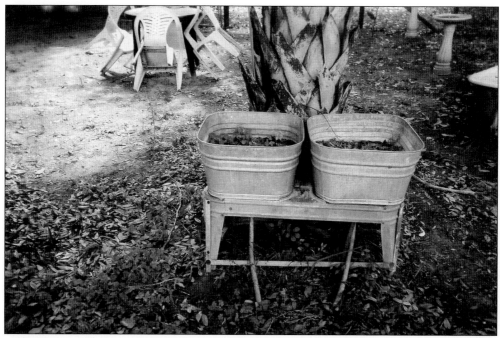

Washtubs were also used before the automatic washing machine was invented; these are owned by Betty Walker in Hardetown. Remembering their use, they are just too hard to abandon.

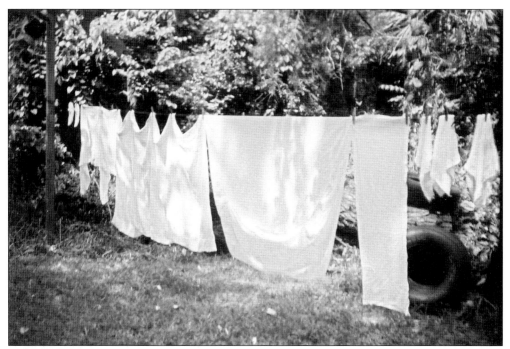

The clothesline was used to hang clothes out to dry before the dryer was invented. Wire was stretched between two trees or two posts and clothes were pinned to the line by wooden clothespins.

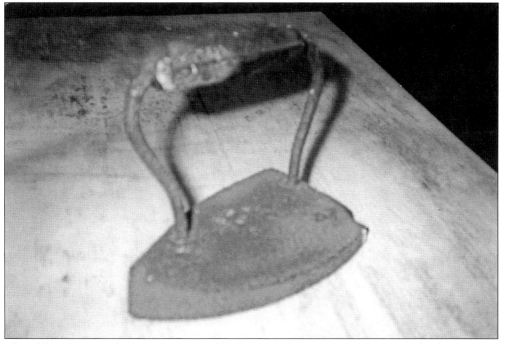

The old Dixie smoothing iron was used before the electric iron was invented. This one was owned by Margaret Gibbs. The iron was heated on a wood stove or in the fireplace.

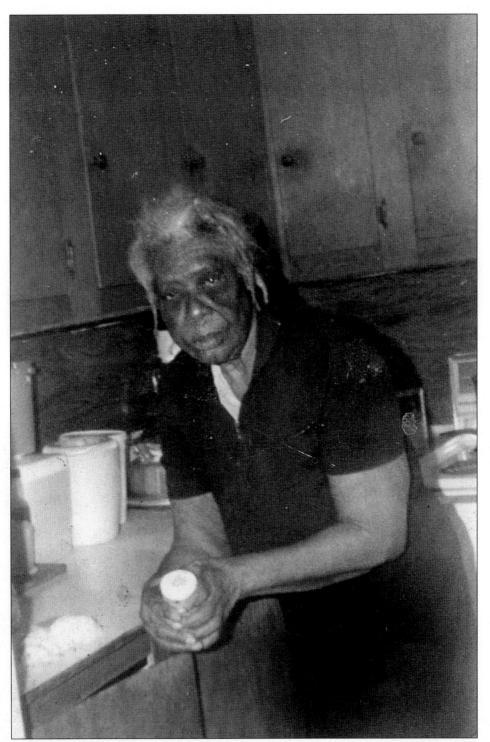

Ola White was no stranger to the kitchen; she worked for Mrs. Idel Beachamp, James Turner, and Charlie Akins. She was from Sumers in Levy County. She also worked as a cook in the local truck stop.

Brother West and Silvia "Doll Baby" West take a break from cooking to take a picture outside of an old boardinghouse. Black cooks were always in demand, and there was nothing that they couldn't cook.

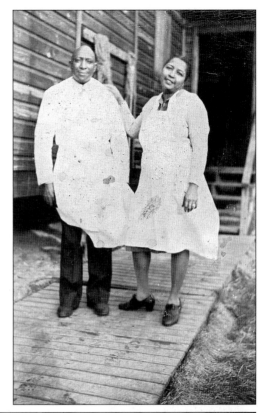

Ruth Gibbs serves Thanksgiving dinner at the Buchannan house. She also worked as a maid for the Usher family, the Drummonds, and the Beachamps. She is well known for her fried chicken and biscuits.

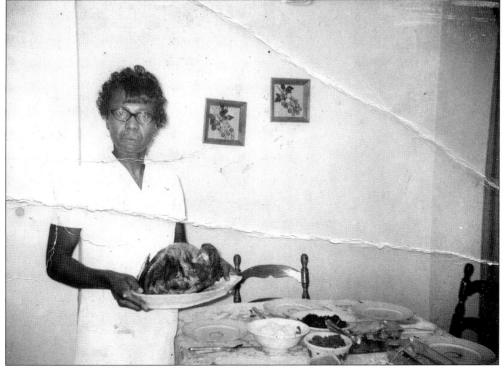

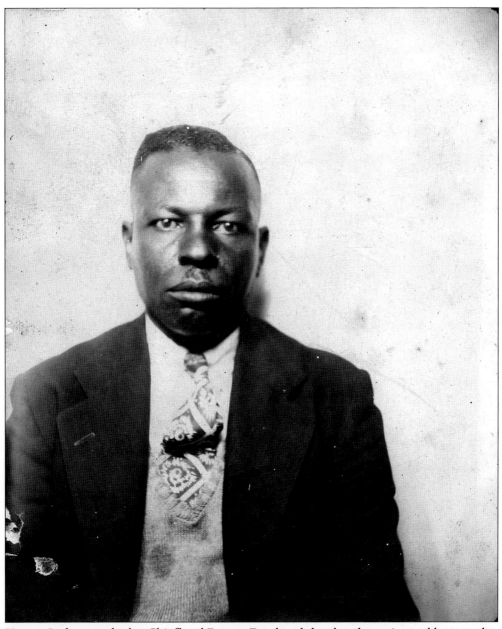

Horace Joshua worked at Chiefland Frozen Food and the slaughter pin, and he was also a farmer. He was no stranger to hard work. He owned land outside of Chiefland, which was called the Highwoods.

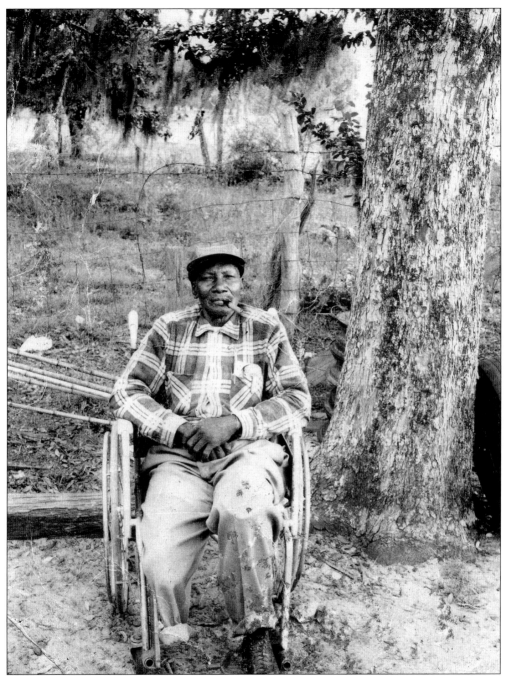

Mr. Precious Wilder worked as a butcher around Chiefland and the tri-county area. Many families were grateful to him for the oxtail, pig feet, hog heads, and other meats that he gave away at no cost. In this community, the gift of sharing was a way of life.

This old hay barn stored many things, including cowhides waiting to be sold. Seeds were also stored and dried there for the next year's planting. This barn still stands, but time has taken its toll.

Smokehouses were used to cure meat, such as smoked hams, sausage, and bacon. A slow smoking fire was used; the meat would be hung inside over the smoke until cured.

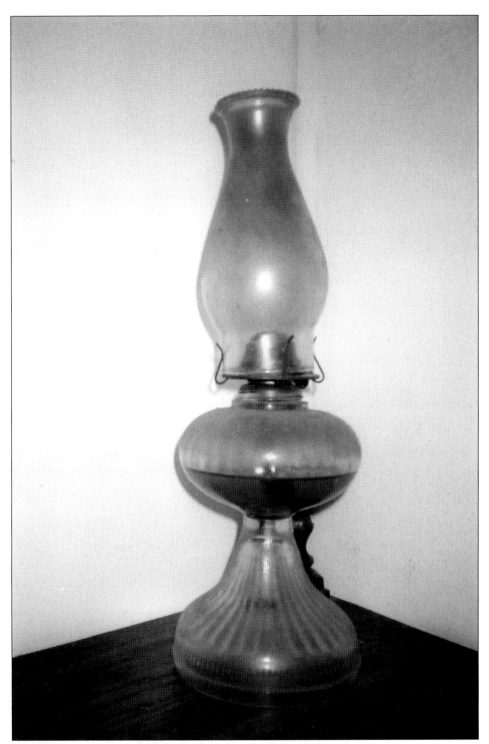

Kerosene lamps were used in the home to provide light before electricity was available. Now oil lamps are used for their beauty and charm. They are a small reminder of the past.

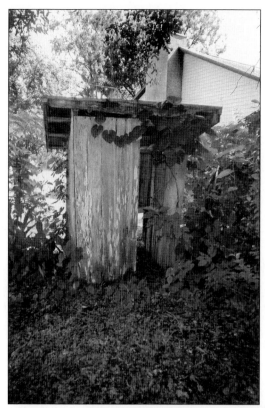

Outhouses were used by many families before indoor plumbing was invented. There are a few that still stand on old homesteads, even though they are no longer used.

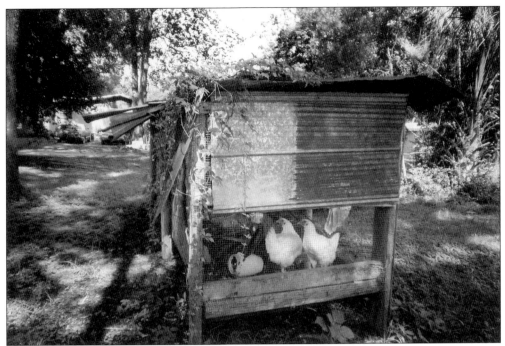

It was nothing strange to hear a rooster crowing early in the morning; many families raised chickens for eggs and meat, often selling the eggs.

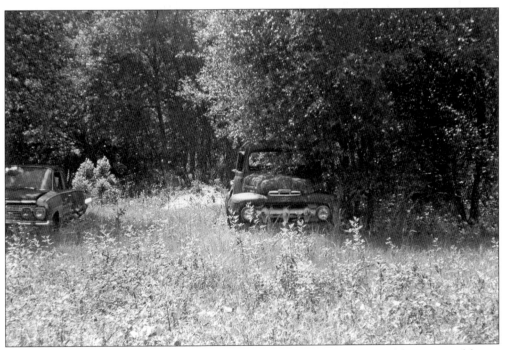

These antique cars, parked under old oak trees, belong to Louise Wilder. Many old cars were parked in fields until their owner could find a better use for them.

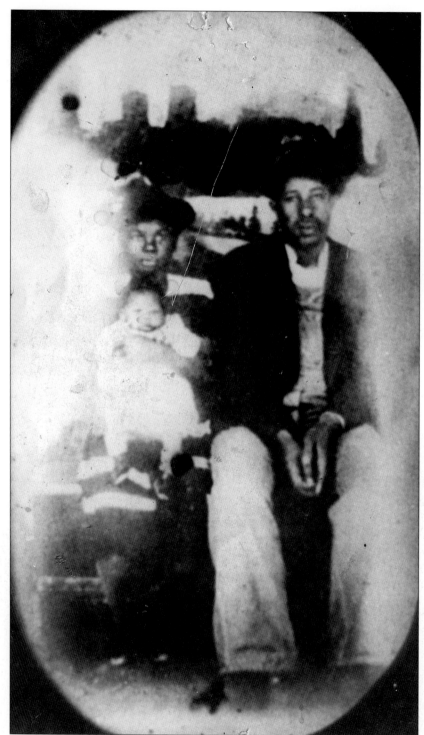

Charlie and Lola Riley are pictured here with their baby. Mrs. Riley was born in 1902; she was the mother of 12 children. Mrs. Riley and other members of the Riley family still live in Hardetown today.

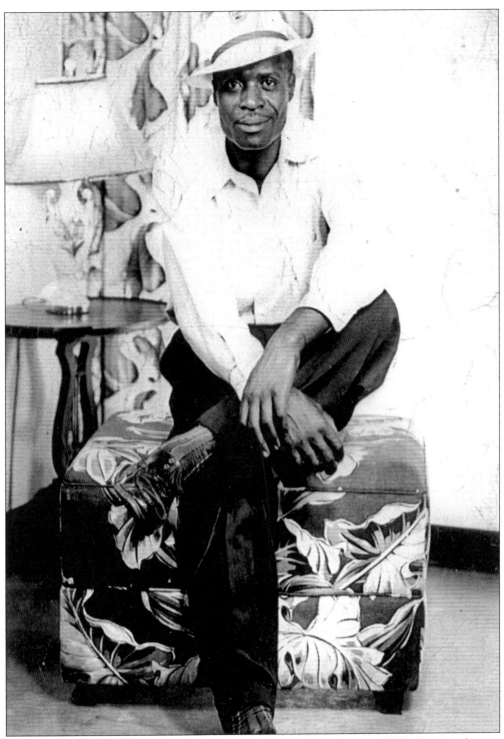

Georgia Boy Clemons is seen after working all week in the woods for S. J. Buchanan Logging Company. There's nothing like getting dressed up for the weekend. Some of Mr. Clemons's offspring still live in Chiefland.

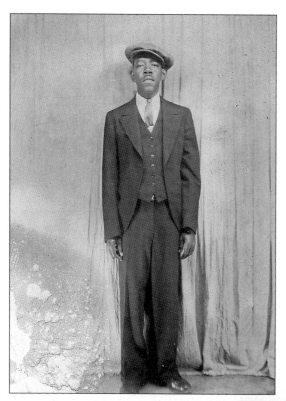

This young man is dressed in a suit, shiny shoes, and a bebop cap. This was the fashion of the time—he was stylish. Fashions have changed over the years, but they often come back with a different name.

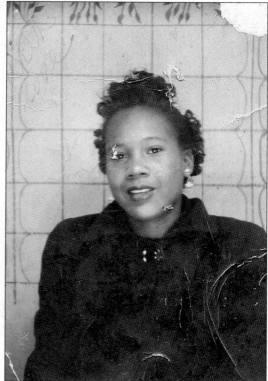

Photograph booths were set up on the side of the road on some weekends; Seretha Mathis stopped to take a beautiful photograph. Many families did not own cameras, which were considered to be a luxury item.

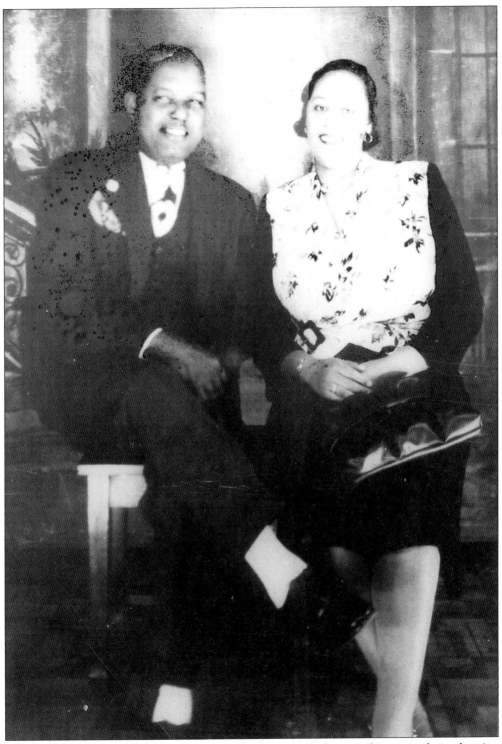

Amos and Elsie Jones were both cooks. The Joneses make a striking couple in the city. Mrs. Jones cooked and catered at the University of Florida for many years.

Two seniors all dressed up for dinner share a moment. Both Deacon U. L. Gamble and Sister Ruth Gibbs are highly respected in the community and the church.

Katrina M. Cohens received the Fulton Strong Award in 1991; it is given every year by Chiefland Men's Club for outstanding academics. She was also a contestant in the Miss America Co-ed Pageant in Tampa.

Willie Pearl Joshua looks pretty in her pearls and prom dress; she was always known for her beautiful hairstyles. Hot combs and curling irons were used before perms were invented.

There is nothing like taking a picture with your sweetheart at the carnival, which would come to town once a year. After the movie theater closed, there were no other forms of entertainment.

This picture shows Catherine Jones not only beautifully dressed but also with a beautiful smile. Catherine was the daughter of Wiggin Jones of Chiefland. She lived in New York City.

A young lady shyly smiles, dressed in her Sunday best with her purse on her lap. Young ladies were taught that it is better to be seen than heard.

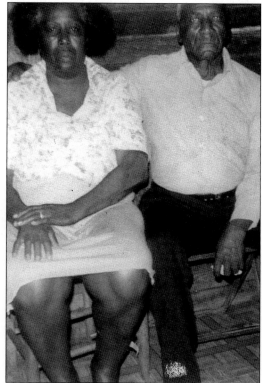

Friends Mrs. Clora Johnson and Mr. George pose for a photograph on a warm summer day. Mrs. Johnson raised her family in Chiefland; many of her children still reside there.

Mrs. Bessie Ann Clemons had a lovely singing voice; she warmed many hearts and brought tears to many eyes. She was called on to sing at many occasions; she always had a smile on her face.

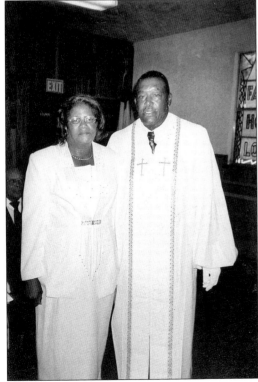

Pastor Walter Hunt and Mrs. Tubbie Hunt are photographed here. Pastor Hunt has been at Mount Pleasant Baptist Church for over 20, since 1981. He makes sure he visits the sick and gives comfort to ones in need.

Asia Powell is the daughter of Katrina Cohens. Her picture has been used for several years to advertise the Fifth Avenue Festival and was featured in the source book, a telephone book that covers several counties. Asia was the winner of the baby competition that was held at the Tommy Usher Center to benefit the Chiefland Child Day Care Center.

44

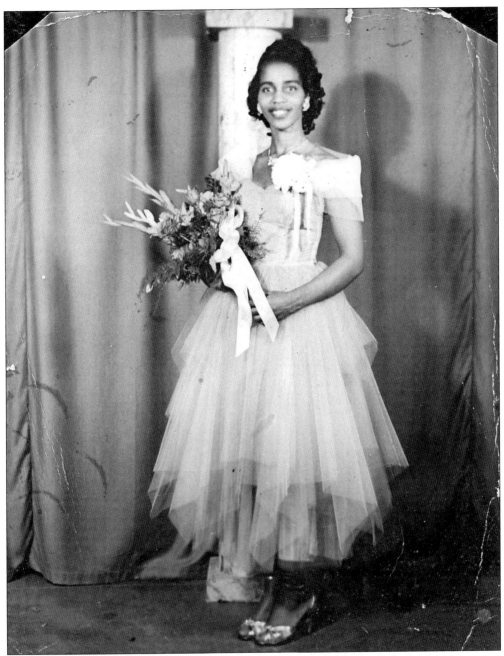

Carrie Wimberly models at the Eastern Star banquet in 1956. She wore a beautiful evening gown that she made; she also makes dolls, hats, and quilts to this day. She has a dream of teaching young black ladies her craft.

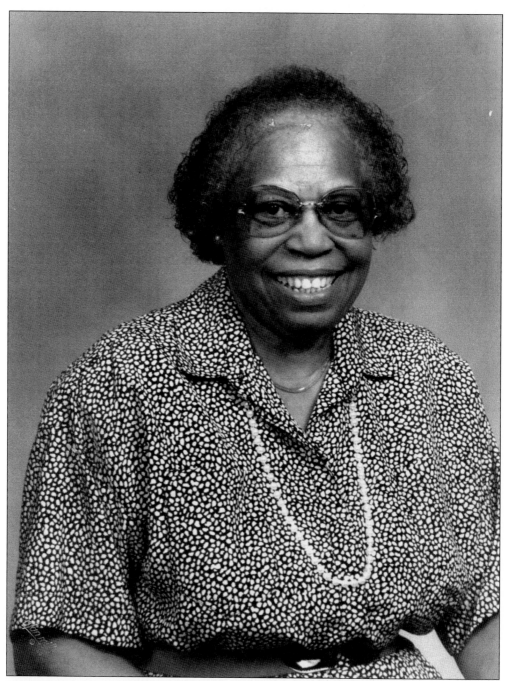

Mrs. Julia Haile made history by becoming the first black elected to the Levy County School Board. She is a retired schoolteacher and was also inducted into the hall of fame at Florida A&M University in Tallahassee, Florida. Haile is active in the community and is a member of many organizations.

Mr. Earnest Haile was principal at Chiefland Junior High in 1957. He was the first assistant principal at the white school after integration in Chiefland. He is originally from the state of Georgia, but he has lived in Chiefland for many years.

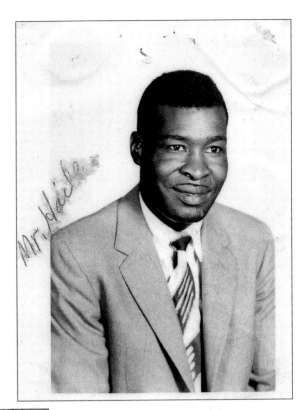

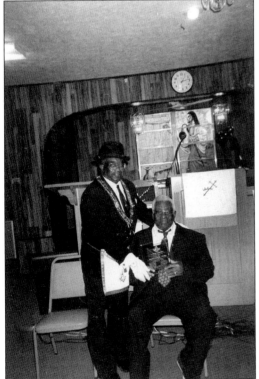

Pictured here are the former wishful master Mr. Joe Eddie Scott (standing) and the late Rev. John Henry Philips, whom St. Philips Lodge No. 607 was named in honor of. Reverend Philips pastored many churches in his lifetime and was loved by all.

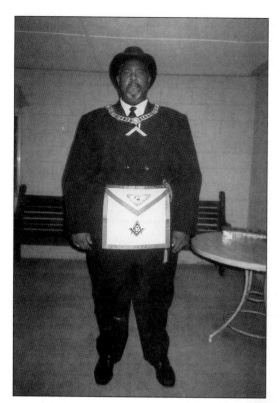

Jeffrey Crawl is the wishful master of St. Philips Lodge No. 607 in 2005. He is walking in the footsteps of many great men. He is employed by Florida Department of Corrections. His home is located in Old Town.

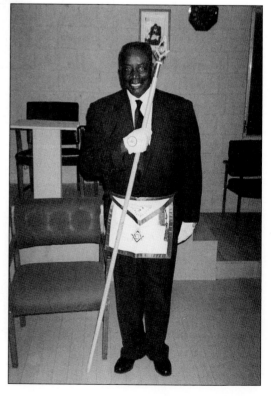

Mr. Theordore Henley lives in Gilchrist County, but he is an active member of St. Philips Lodge, which is located in Chiefland. He is an outstanding citizen, has been highly recognized in his community, and received numerous rewards.

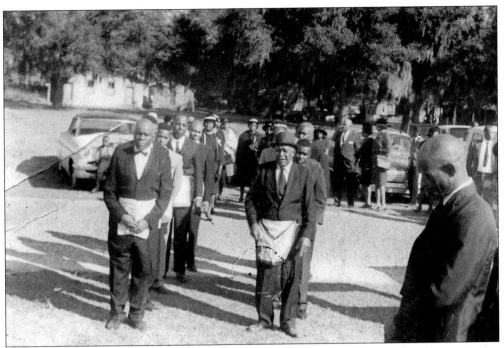

Masons of St. Philip Lodge No. 607 turn out for the homegoing of a brother mason at Mount Pleasant Baptist Church. The wishful master Albert Young and Mr. Link Mungen lead the procession. The masons have been in existence for over 60 years.

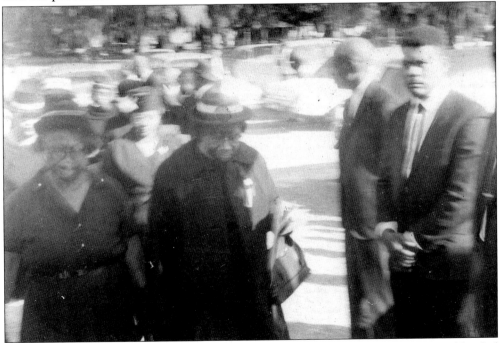

The Heroines of Jericho turn out for the homegoing of brother mason Amos Gibbs, led by head matron Mrs. Marie Mungen (left) and Mother Ida Bell Devon (center). Mother Devon was also a midwife for many years in Levy County.

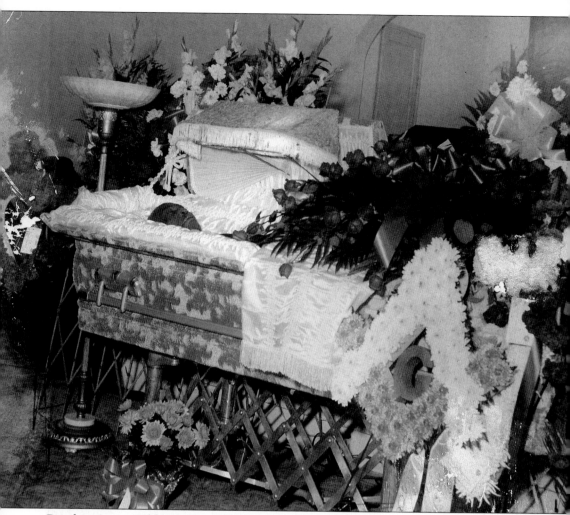

Brother Amos Gibbs was a mason in good standing, very well known, and highly respected. He was the first black contractor in Chiefland. Mr. Gibbs worked very hard in the community.

Two

ROSEWOOD AND CEDAR KEY

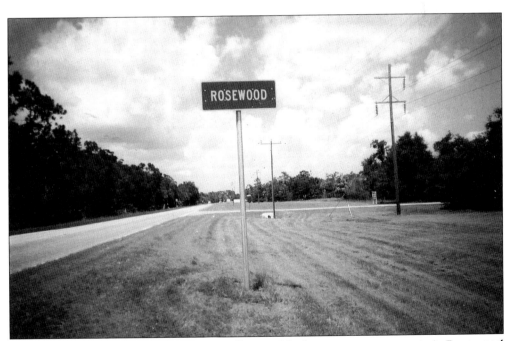

The community of Rosewood is very small. Many blacks use to own property in Rosewood until the tragedy when many blacks were killed by white assailants from neighboring towns. The whole town was burned, and many residents lost their lives and everything they owned there. There is a small cemetery still remaining in Rosewood.

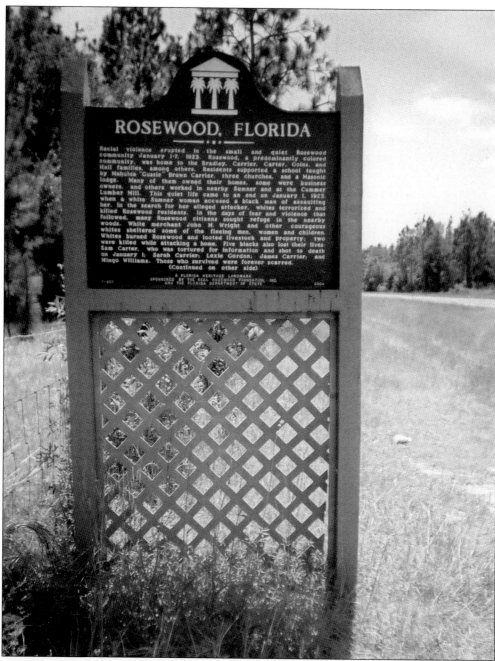

This historical marker was placed in Rosewood to honor those who lost their lives in violence that erupted after a white woman, Fannie Tailor, accused Aaron Carrier, a black man, of assaulting her. Fannie's husband, James, called in friends and their dogs from a nearby camp to track the accused assailant. As a result, black home and business owners and other residents of Rosewood were attacked and killed. In an effort to preserve history and to honor the victims, this marker was erected in Rosewood in May 2005. Florida governor Jeb Bush was present at the unveiling, and many bus tours are taken to Rosewood to visit the marker and the site of the tragedy.

Artist Jenkins welcomes visitors to the Cedar Key arts festival. Many tourists come from all around to enjoy the island, arts, crafts, and the delightful seafood. There is an annual seafood festival held in Cedar Key.

The Cedar Key Keyhole is one of many shops on the island. Many artists and craftsmen display and sell their work at the Keyhole. Many tourists visit the Keyhole to see the arts and crafts. Author Carolyn Cohens was a member in the past.

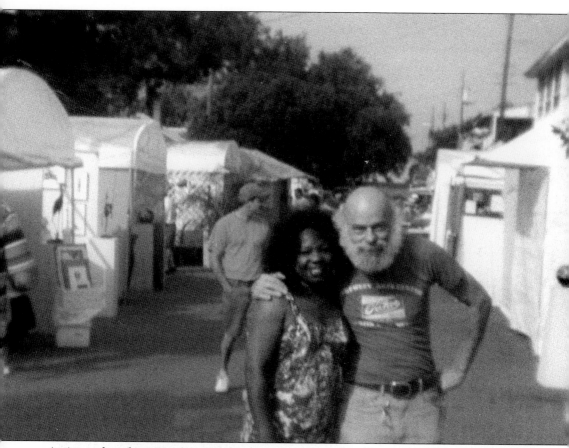

Artist and author Carolyn Cohens has participated in the Cedar Key arts festival for several years. Everyone showed a great appreciation for her artwork. Ms. Cohens's art was also featured in the Cedar Key Keyhole.

Three

BRONSON

Edith Brown was the first black mayor in Levy County. She served in Bronson, which is the county seat of Levy County. Ms. Brown worked for the Department of Agriculture for 31 years and currently works for the Levy County Sheriff's Department.

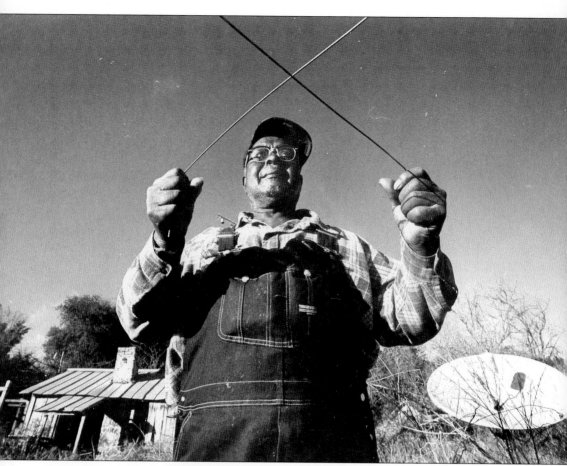

Leroy Dude was a well driller, and in this photograph he engages in the art of witching. This is a method of using wooden sticks or metal rods to find water. His grandsons continue to carry on the family business.

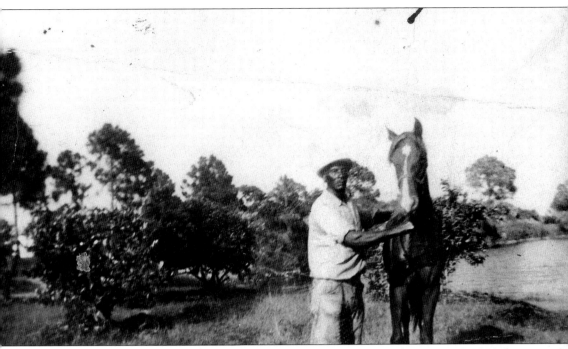

Vander Hunter stands with pride beside his horse. Mr. Hunter was born May 5, 1872; he moved to Chiefland in 1937. He worked as a wood rider, keeping records on turpentine woods, in Six Mile Still, which is located six miles from both Chiefland and Otter Creek Sawmill. Some of his family still lives in Levy County.

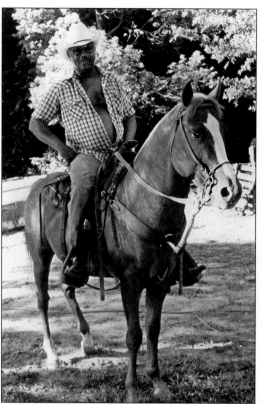

R. L. Stacey sits proudly on his horse, Billy Bo Jangle, in 1989. Mr. Stacey trained horses to do many tricks. He was known to many in Bronson as the "Black Cowboy;" he took great pride in his work.

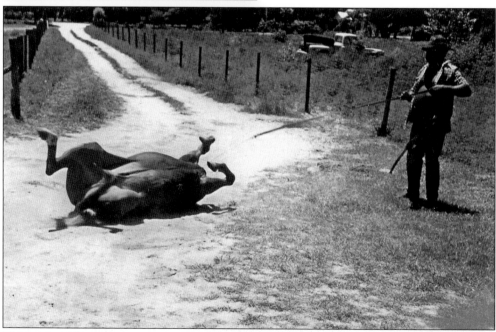

This picture features Mr. Stacey training Billy Bo Jangle to roll over. He also worked on Luther White's farm breaking horses for many years. He is now retired, but he still has a great love for horses.

Charlie Durr and R. L. Stacey are dressed and ready to go hunting. Levy County woods are a hunter's paradise full of wild game. Many black men love hunting and fishing. Hunting and fishing provides food for the family as well.

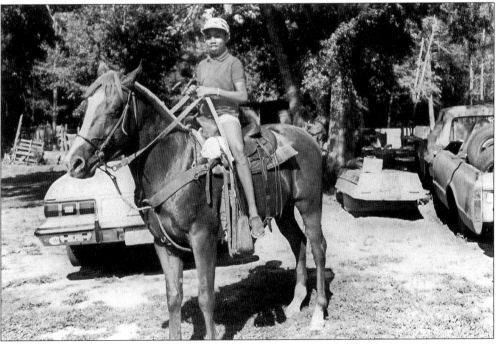

Reginald Stacey loved horses; he is photographed on his dad's horse in Bronson, Florida. He learned at an early age to appreciate horses, and he learned to ride very well.

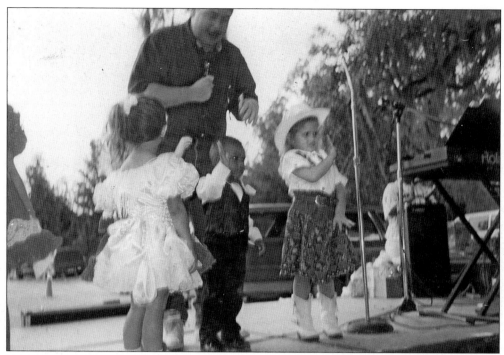

Enrique won the title of Little King at the fall festival in 1994; he was two years old at the time. The festival draws a large crowd from around the county. Enrique was brave, answering all the questions, and he won by a majority vote.

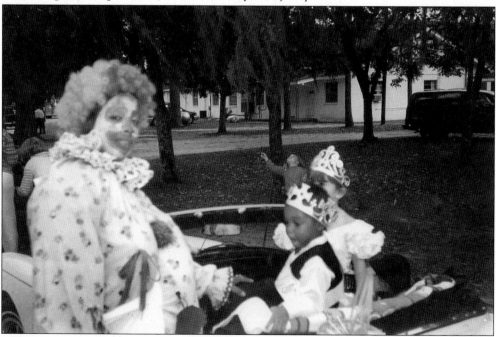

The little king and queen ride in the parade with a clown. Everyone loves a parade, especially the candy tossing. Parades in Levy County are big events; there are always many spectators.

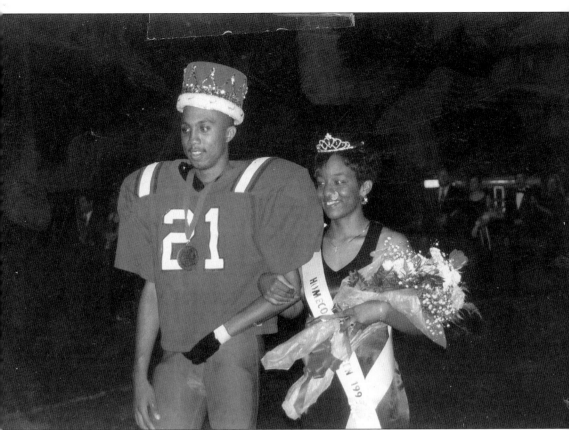

Reginald Stacey was crowned homecoming king in Bronson, Florida, in 1996; he is featured with Markeisha Mitchell. He is well known in Levy County for his sportsmanship.

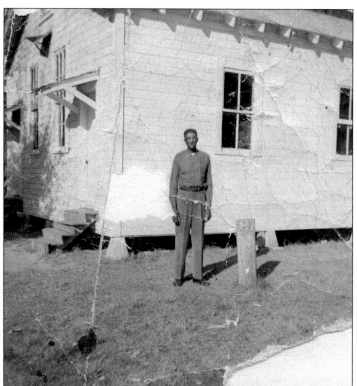

Deacon Mack Dixon stands outside of the Church of God by Faith in Bronson, Florida. Mr. Dixon was well known in the community, and he was also a minister.

Mother Janice Dixon is photographed outside of the Church of God by Faith in Bronson. She was loved by many, and she was always willing to lend a helping hand.

Annie Lee Lane dressed in a summer dress and socks at a time when young girls wore socks until they reached their teens. The tradition was for a young lady to get her first pair of heels at the age of 16.

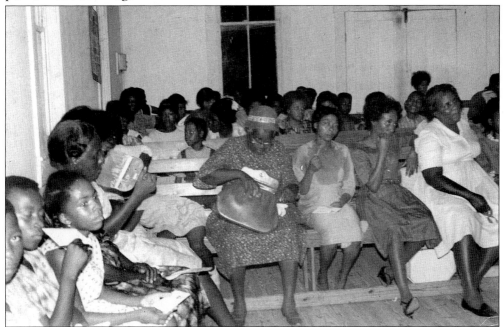

Revivals at the Church of God by Faith always filled the church. Everyone looked forward to great singing and preaching. People would come from all around the county to take fellowship with each other.

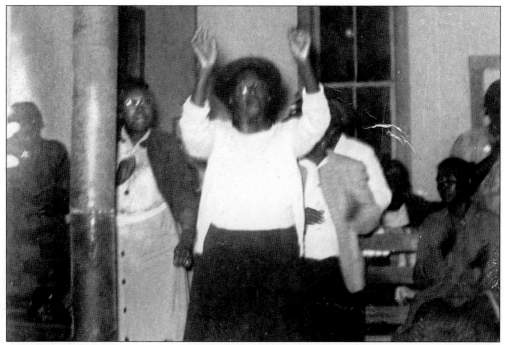

Mrs. Mamie Follins is touched by the spirit and shouts around the wooden heater. She was the mother of the church and was always helpful to those in need. She lived a long and fruitful life.

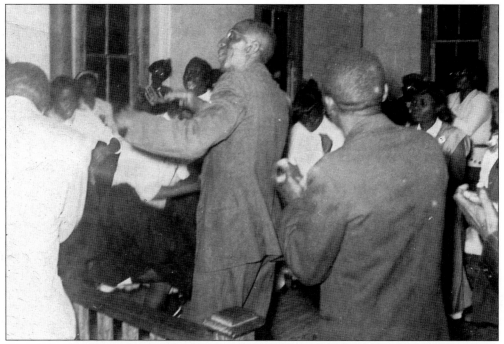

Brother Bubba Johnson and Brother Sal Davis sing and praise the Lord for their many blessings. There is nothing more heartwarming than an old hymn song by an elder. Today the songs are more upbeat, and hymns are becoming a thing of the past.

Children are featured standing in front of New Sepulcher Church of God, which is located in Bronson. Bishop Max Dixon was the minister for many years; everyone loved him.

One of the Duke twins, either Terry or Jerold, waits patiently to go inside the church to play the guitar he received for Christmas. To this day, he still loves music and plays the guitar.

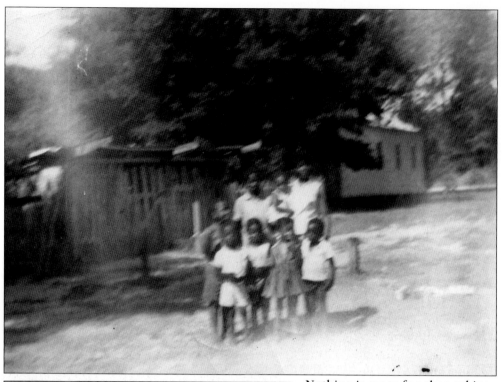

Nothing is more fun than taking pictures. Included here, Loretta Dukes, Terry Dukes, Jerold Dukes, Lyn Glover, Sharon Glover, and Mike Glover smile happily. They loved to play outside until after dark; their mom would have to call them in.

Little Reginal "Turbo" Scott strikes a pose in his Sunday best. Turbo is now in college and pursuing a degree in culinary art in Miami. When he is not at school, he enjoys cooking for his family and showing off his skills.

Lauren Henley smiles happily as she poses for the picture. Lauren takes ballet and loves to play dress up, talk on the phone, and play with her friends.

Juanita Dixon stands proudly after graduation from Hampton Junior College in 1965. She worked at Sunnyland from 1968 to 1971, Landcaster Youth Development from 1971 to 1979, and Health Rehabilitive Services from 1979 to 1994.

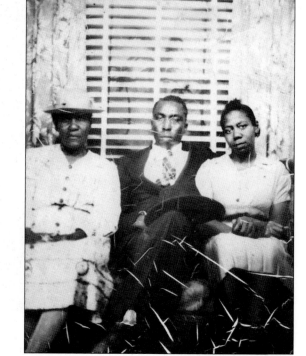

Richard and Josiphine McClendon are pictured on their wedding day accompanied by Mrs. McClendon's mother, Minnie Pringle. Mr. and Mrs. McClendon made their home in Bronson and raised their children there.

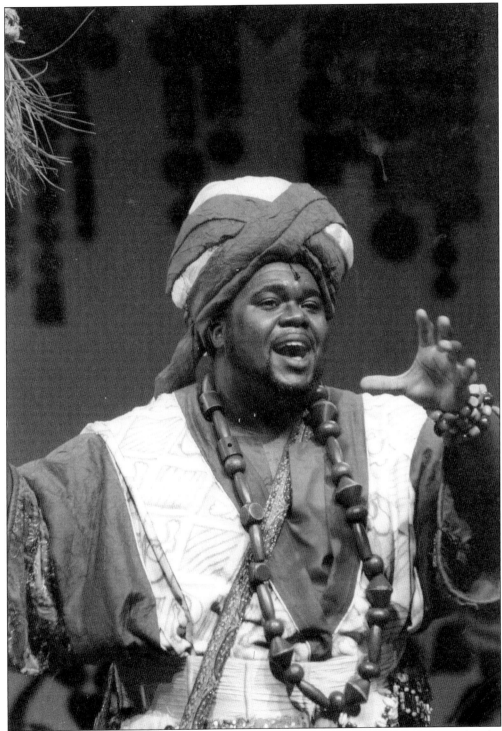

Frank Edmondson Jr., born October 8, 1971, performs at Bush Gardens in Tampa, Florida. He is an actor and singer. He started his career in Chiefland with the Suwannee Valley Players. He was featured in *The Solider Story* and *To Kill a Mockingbird*.

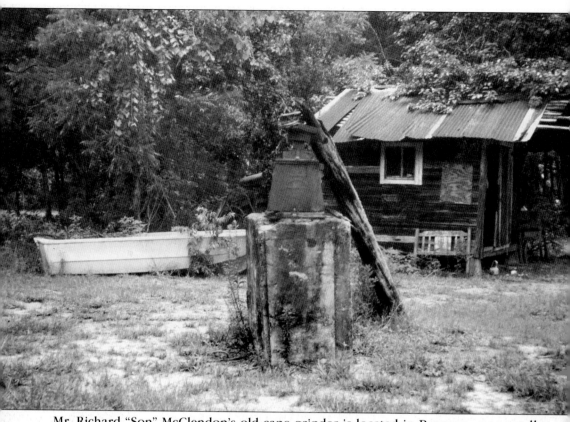

Mr. Richard "Son" McClendon's old cane grinder is located in Bronson; many stalks of cane were used to make syrup. He also made syrup for other cane growers around the community.

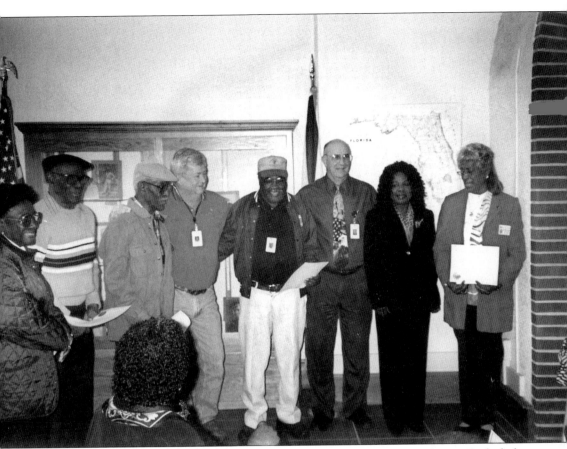

During Black History Month, soldiers are honored at the Levy County courthouse. Included here from left to right are Inez McNeil, U. L. Gamble, Ethorn Buie, George Hermeson, Clerk of Court Danny Shipp, Carolyn Cohens, and Eddie Jean Williams. Pictured here are family members and veterans receiving certificates for their contributions.

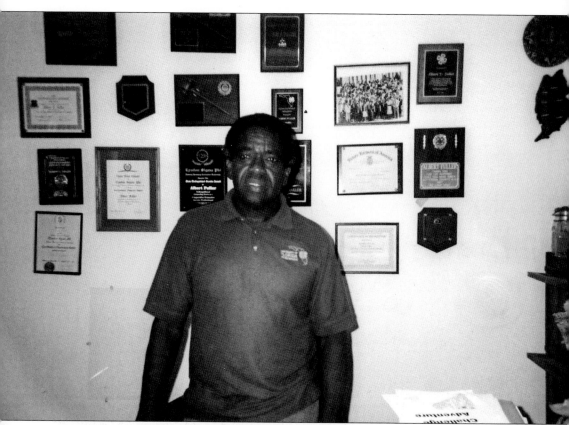

Albert Fuller is the grandson of Fulton Strong and the great-grandson of Dan Strong, who was a freed slave and business owner. Albert Fuller served as extension director of Levy County and 4H coordinator for 18 years. He developed an international private consulting business that specializes in leadership development and team-building training.

Four

WILLISTON

Jacob "Jake" Dotson was born
into slavery. Even though
Mr. Dotson never learned
how to read or write, he
became a landowner. Some
of his offspring—Thomas and
Delores Days—live in Raleigh,
Florida. He lived to be a 109.

Fred Matthews was born in Otter Creek, Florida. He served as the president of the local NAACP for 10 years. His wife, Patricia Matthews, is a schoolteacher. Mr. Matthews is well known in Levy County for his hard work, honesty, and integrity.

Lewis and Nora Carnegie are featured in this photograph. They worked as custodians at Williston Vocational High School and are the grandparents of the owners of Carnegie Funeral Home in Chiefland, Florida.

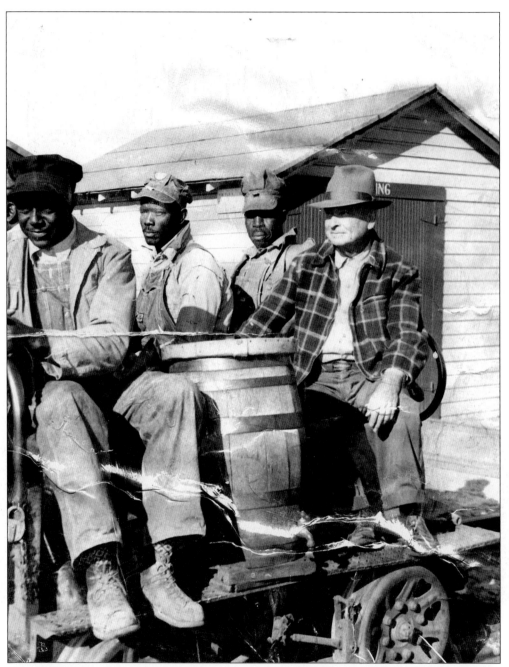

Calvin Hammonds is pictured sitting second from the left on a motorcar in Morriston, Florida, where he worked on the railroad. He worked hard for many years, and some of his family still lives in Williston.

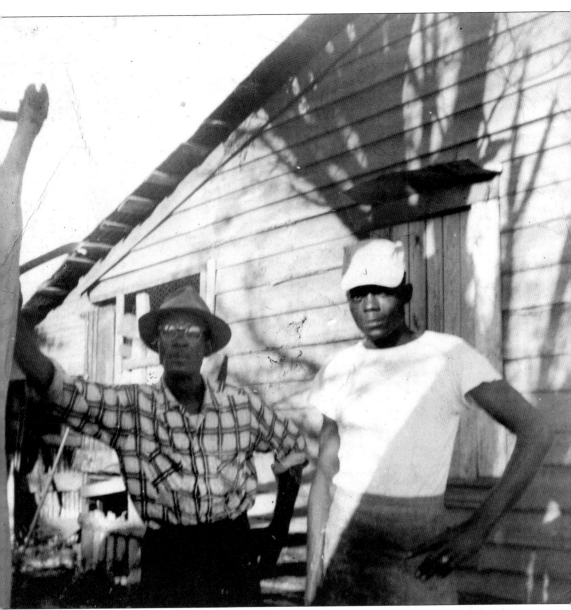

Raleigh Wallace Sr. and his son, Raleigh Jr., were butchers in Williston, Florida; they butchered for as many as 58 people all around Levy County. Raleigh Sr. was well known for his work, and he trained his son to follow in his footsteps.

Raleigh Wallace Jr. smiles as he makes one hungry showing off two sides of country-cured bacon at the Little Pig Feet Farm. Mr. Wallace still lives in Williston on his farm, and he owns many horses.

Eric Wallace, shown here preparing a hog for butchering, is the third generation of butchers in the family from Williston, Florida. Eric is proud to carry on the family business; it is one that will always be needed.

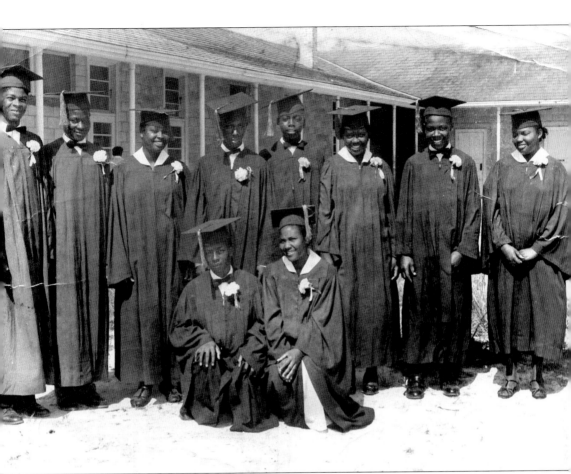

This is the 1960 graduating class of students that were bused to Williston, Florida. Included in this photograph from left to right are R. L. Gent, Nathaniel Mathis, Inetha Robinson, Marcus Mattox, James Phillips, Mary Lee Mitchell, J. D. Daniels, Delores Pete, Leroy Pinkney, and Beatrice Henderson.

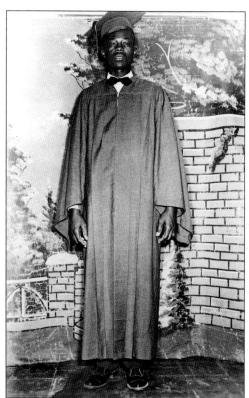

Raleigh Wallace Jr. graduated with a class of nine at Williston Vocational High School. It was a very proud day for his family. Receiving a diploma is a great achievement, because education is very important.

This picture features a group of friends taking a minute to pose at school. The students, from left to right, are Virginia Carnegie, Harold Luckey, Annie Lee Lane, and Alfred Battles.

Mrs. Scott smiles while giving motherly advice to her students at school while taking in some sun. This was a time when children respected and listened to their elders for guidance.

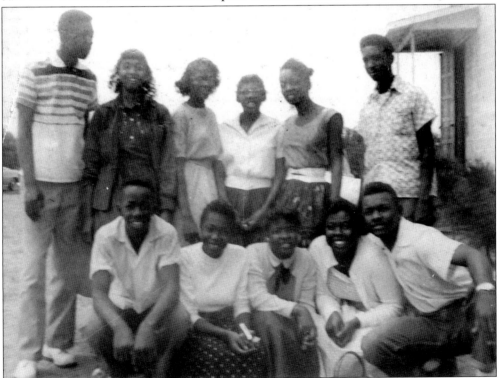

Here is a group of friends taking a moment to capture smiles and everlasting friendships in a picture that will say a thousand words. Not everyone owned a camera, so no one missed the opportunity to take a photograph.

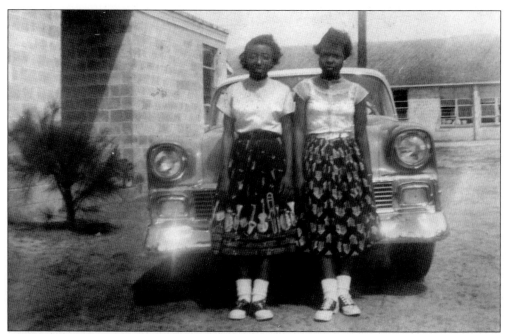

Standing in front of a car, two best friends seal their friendship with this photograph at Williston Vocational High School. They are Juanita Dickson (left) and Annie Lee Lane; these ladies are still friends today.

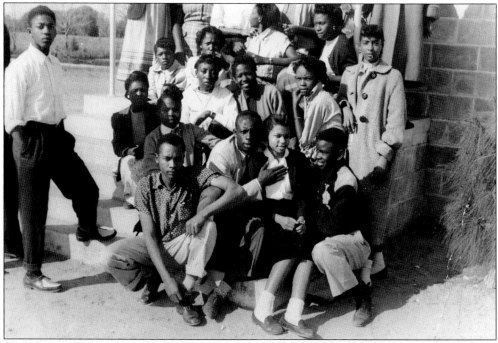

This photograph is of the Williston school chorus in 1956 and 1957 with their teacher and director Margaret Willis. Ms. Willis is seated second from right in the top row. There were always many students willing to participate in the chorus to show off their lovely voices.

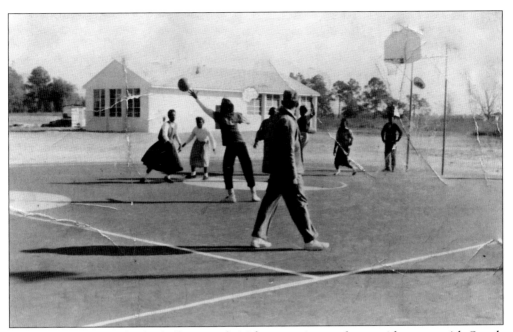

Featured here is the basketball team of 1956 at practice on the outside court with Coach Lomonica Cartwright. There were always spectators, and former basketball stars always coached from the sidelines.

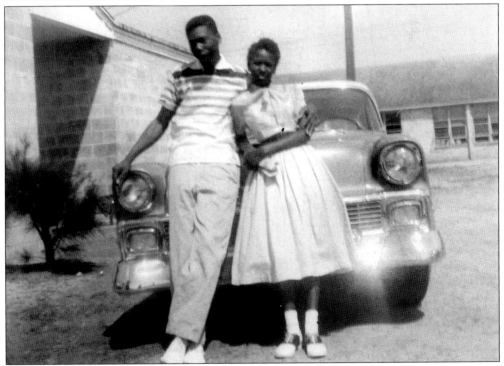

Alfred Battles and Dorothy Davis are leaning against a 1956 Chevrolet while taking a break at school. School seemed hard, but no one wanted to miss it, especially since all of one's friends were there.

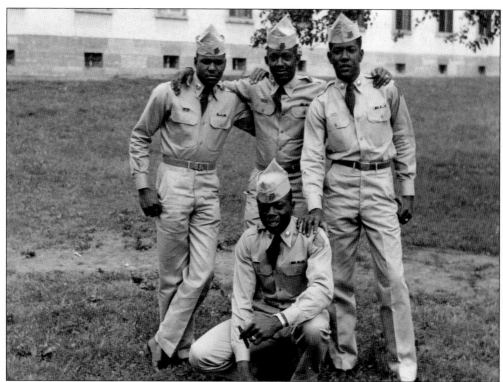

Raleigh Wallace and his army buddies, dressed in their uniforms, called themselves "the Rat Pack." These young men served their country with pride. The military promoted discipline and the offered opportunity to travel.

Frank Graham was employed by a logging company in Morriston, Florida, for 10 years, and then he worked for Dixie Lily Milling Company for 21 years. Many of his offspring still live in Levy County.

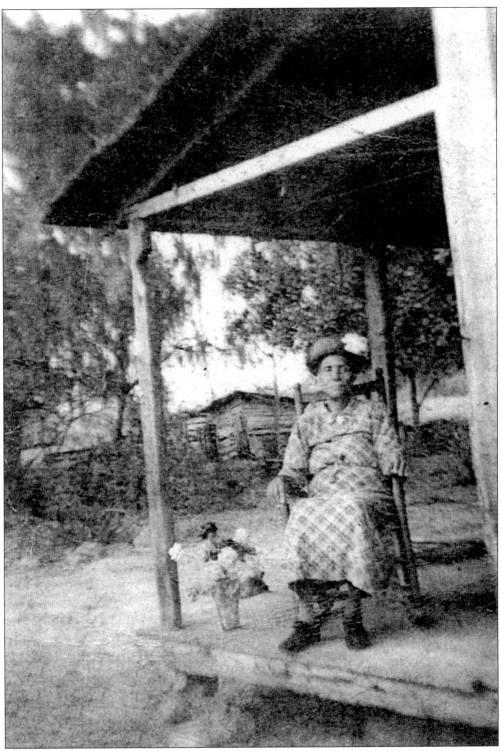

Fannie Hunter Hammonds sits on her front porch all dressed up with a bouquet of fresh flowers to enjoy. Sitting in her rocking chair was one of her favorite things to do.

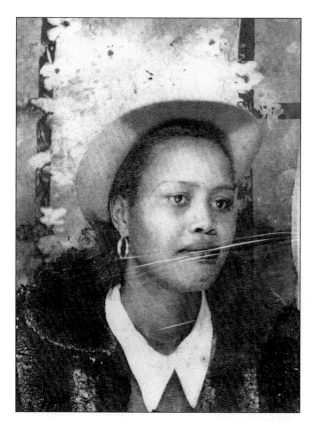

Katie Hammonds Graham is dressed for church with her hat and fur jacket. She was born September 2, 1917. She was a housewife and a mother. Some of her children and grandchildren still live in Levy County.

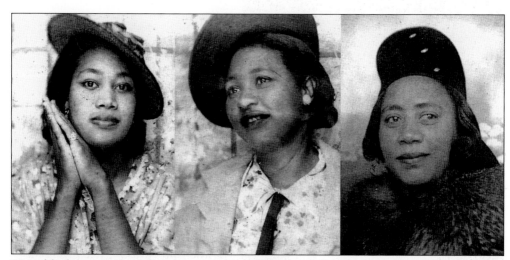

Many black women love their hats and consider them their crowning glory. Here are three sisters—Josephine (left), Pearlie (center), and Viola Hammond—with three different but truly beautiful hats. The Hammond sisters took much pride in looking beautiful.

Hanky Hammond and a friend are featured in a picture of perfection, all dressed up with somewhere to go in Hanky's 1949 Ford. Hanky was the brother of Katie Hammonds. He always made sure his wardrobe was in style.

Annie Mae Patton has been a member of Mount Pleasant Baptist Church since 1997. She is the president of the pastor's aid ministry, vice president of the Usher ministry, and treasurer. She enjoys visiting the sick and is employed by a hospital in Gainesville.

Virginia Carnagie smiles for school picture. She started working for O. B. Samuel in 1953 in Williston, Florida, as secretary and lady attendant. She also works at the Levy County Courthouse in Bronson.

Five

SIX MILE STILL
AND OTTER CREEK

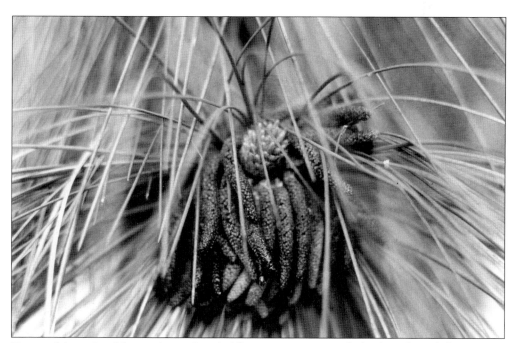

Pictured is a pine bloom (sterminite). The pine tree provided a lot of work for men in Levy County. Dipping turpentine, hauling pulpwood, and cutting crossties was a way of life for many men in Levy County.

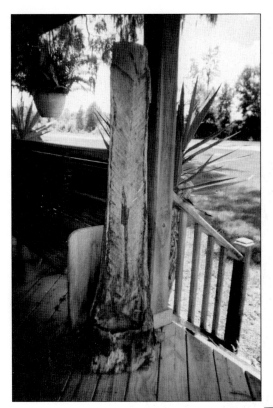

This pine tree was chipped for turpentine in the 19th century; the bottom of the tree was cut out to collect the turpentine before the use of cups. This tree was photographed at Andrews Land and Timber.

Pine trees with these markings are called cat face. The metal on the trees were called tins, and clay pots were used to collect the turpentine that drained from the tree. Black men worked hard shipping and collecting turpentine. This method is no longer used.

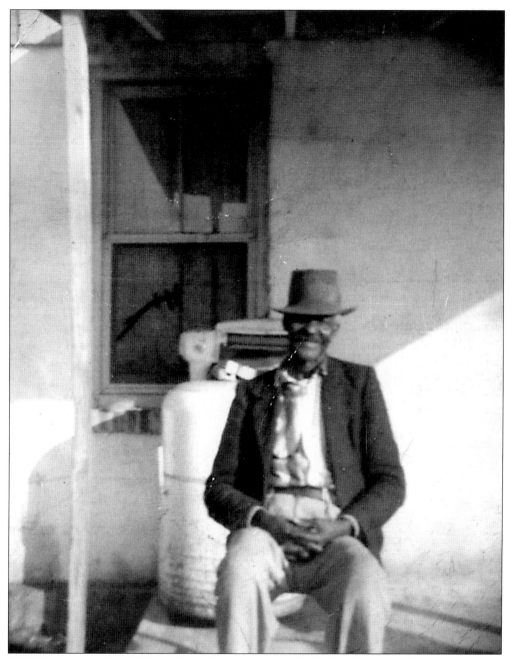

Mr. Robert James Donaldson dipped turpentine in Six Mile Still. He lived in a settlement called Sumers and died in February 1962. Behind him sits an old washing machine. The ringer-type washing machine was used before the invention of the automatic washing machine.

Herman McClendon was born in 1943, and he dipped turpentine at the age of nine with his father in Six Mile Still. His family moved to Chiefland, Florida, and he still works with pine trees for Andrews Land and Timber.

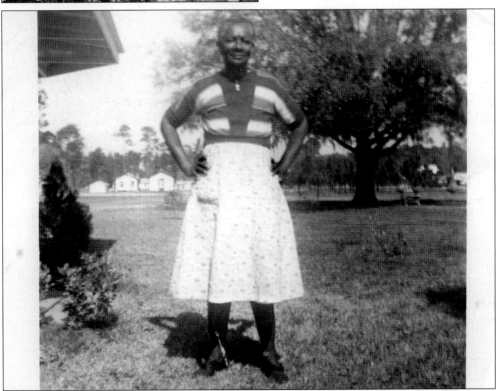

Willie Moore, known as Aunt Willie, was brought to Six Mile Still by M. D. "Six" Andrews. After his retirement, she stayed on and worked for Charlie Akins as a cook, housekeeper, and babysitter.

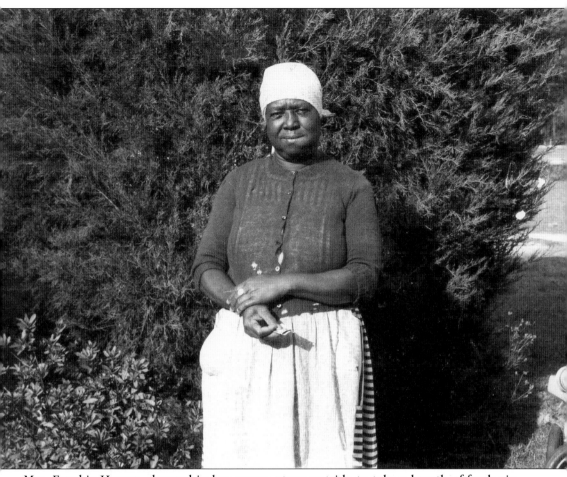

Mrs. Frankie Homes, dressed in her apron, steps outside to take a breath of fresh air. Cooking, cleaning, washing, and ironing were a way of life for many black woman of this time.

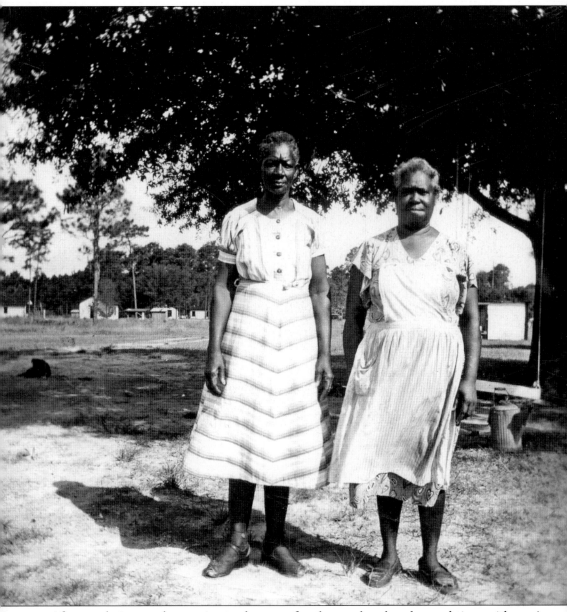

After work, it was always nice to dress up for the weekend and spend time with one's family. It has been said that a woman's work is never done—she worked from sunup to sundown.

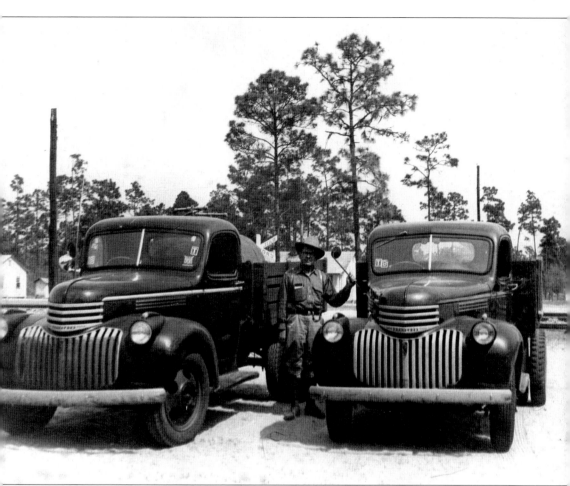

Two trucks are parked after being washed and shined, which meant they were to be admired in Six Mile Still. The commissary is featured in the background. A commissary was a store that carried everything from shoes to food.

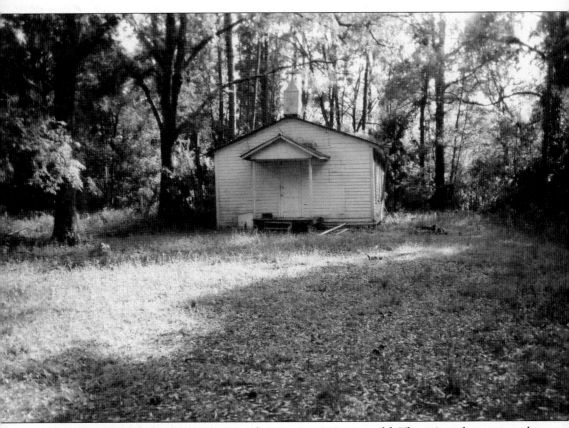

This church still stands in Otter Creek; it is over 100 years old. There is only one member still living: Mrs. Dorothy Strong of Otter Creek, Florida. Mrs. Strong is the caretaker of this church.

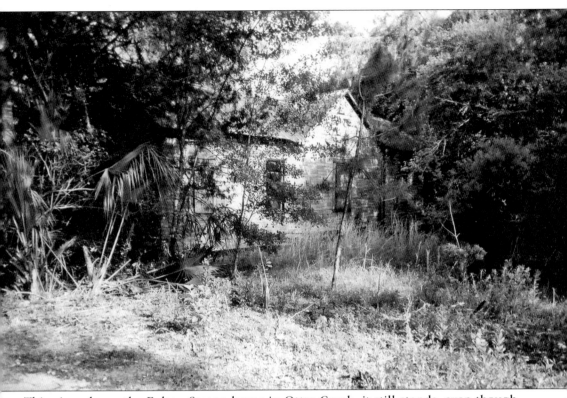

This view shows the Fulton Strong home in Otter Creek; it still stands, even though it is partially hidden behind the trees. His son and daughter still reside near their father's home.

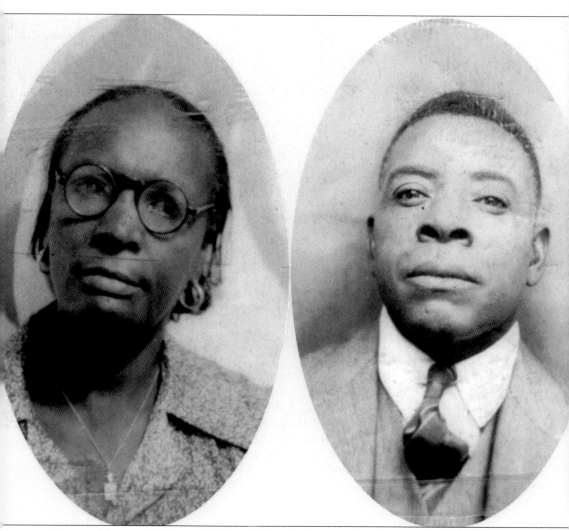

Pictured here are Fulton (right) and Zannie Strong. Mr. Strong is a descendant of Dan Strong, who, with his brother Robert, was a slave when he arrived in Levy County in 1850. The Strong brothers were given their freedom after the railroad was completed.

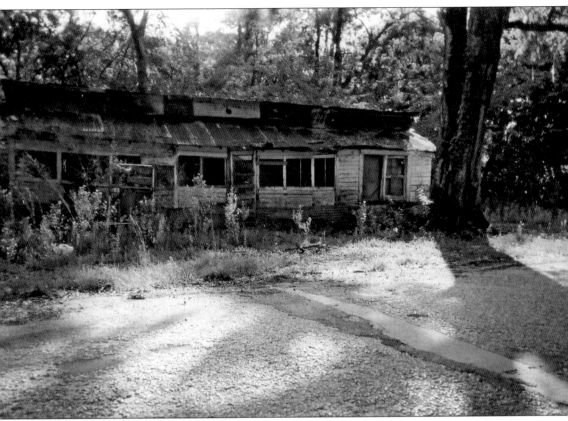

This view shows the old home place of Ruth and Charlie Scott in Otter Creek. The family has moved away, but the land still belongs to their son, Walter Scott. Walter Scott is a graduate of Florida State University and has a master's degree in business. He is currently seeking a law degree.

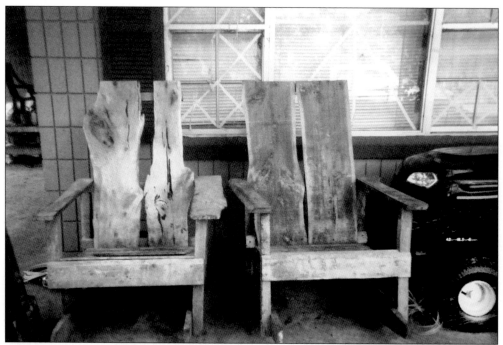

These chairs grace the porch of Mr. and Mrs. Henry Strong. The Strong family home is one of three homes still occupied in Otter Creek. Mr. Strong works at the Levy County Courthouse in Bronson.

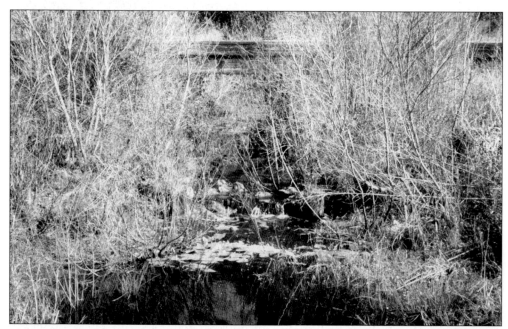

The waterfall is a great spot for catching catfish. The train passed over this small stream many years ago, and it was not unusual to see many people fishing from the train tracks. The train tracks have been removed because the train no longer runs through Levy County.

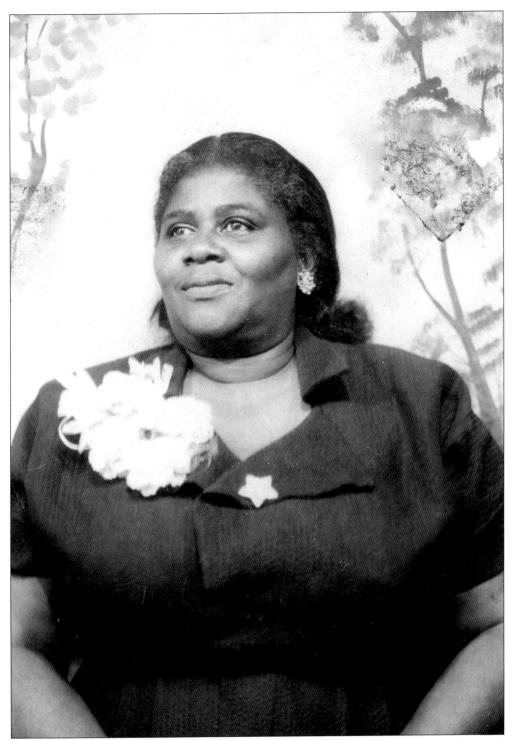

Mary Lifridge was born in 1902; she was a member of the Order of the Eastern Star and is wearing her Eastern Star pin. Her home was in Gulf Hammock, Florida. She was the mother of Carrie Wimberly, who now lives in Chiefland with her daughter.

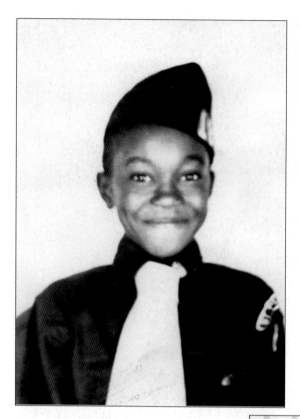

Robert Lueallen, all smiles, is pictured here at 10 years old wearing his Boy Scout uniform. This was the first step in teaching young boys to become men and give them knowledge of the outdoors.

Edward Bubba Nelson (left) and Benny Brown belonged to the Boy Scouts. It was a lot of fun camping out and going on field trips. The boys also enjoyed learning about plants and wildlife.

With arms spread wide like an eagle's wings, Reginal Scott shows how to jump hurdles. In life, there are many, and this is the way we do it. Reginal Scott was the first black drum major at Chiefland High School.

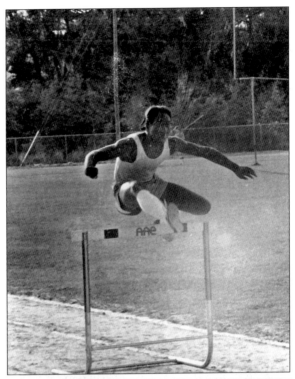

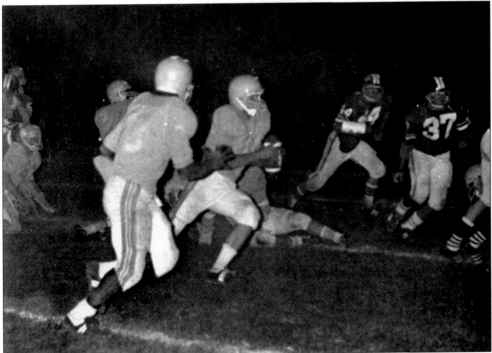

The old and the young love football games; the stadiums are packed with spectators. The popcorn and hot dogs are great too. Everyone looks forward to the halftime show, which always receives a standing ovation.

Lucy Dawson is a Christian lady; she is a member of the prayer band, which is held at a different house every week. They can be heard singing from over a mile away. Many have joined the church after enjoying the prayer band services.

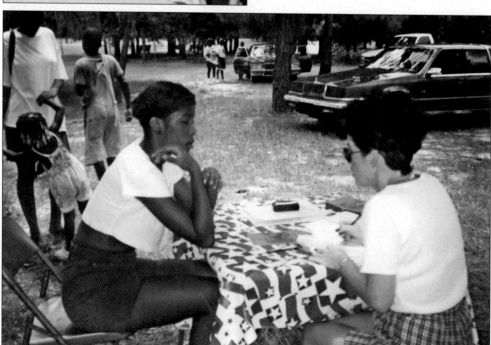

A young lady discusses voting rights with the supervisor of elections, Connie Asbell. Mrs. Asbell would visit Buie Park to register new voters at Chiefland Men's Club festivities.

Theron "Tucker" Thompson sings and dances. He had a voice reminiscent of Nat King Cole. He moved to New York and managed a dry cleaning business, but he returned home after retirement.

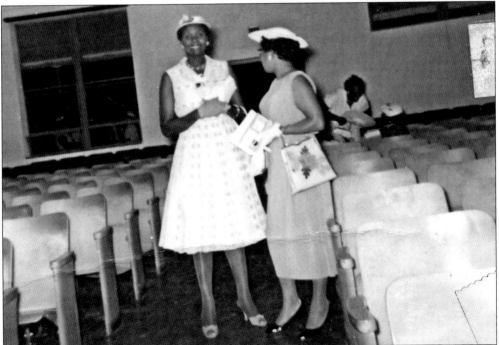

Two ladies in deep discussion stand in an auditorium at Chiefland High while waiting for the play to begin. Everyone looked forward to the drama club plays and chorus. It was wonderful to see little children at their very best.

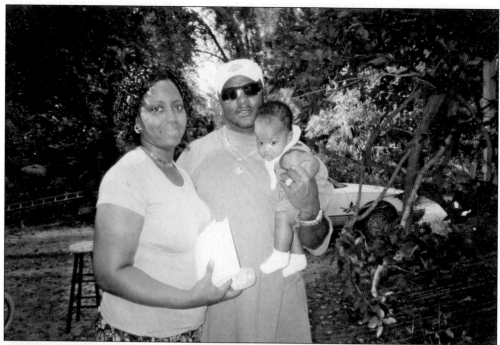

A young married couple poses with their young son, Isaiah. These new parents are very prideful showing off their first-born son. A strong family bond is important.

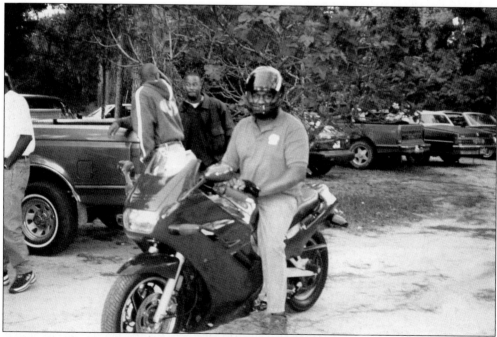

Willie Byrd, a local disc jockey and motorcycle rider, meets up with other bikers from different counties at the Gallery for a friendly race in the country. Mr. Byrd is a member of the Chiefland Men's Club and is the head mechanic at Suwannee Lumber in Cross City.

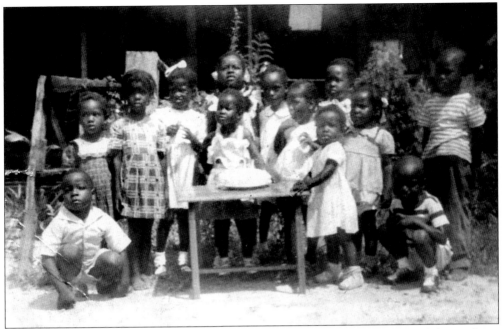

Little ones stand around the table with birthday cake, and on the count of three, there are nothing but smiles. After eating cake and ice cream, it is time to play and have more fun.

Little Edward Nelson stands behind cars of the time. He grew up and became a business professor at Florida A&M University in Tallahassee, Florida, which is where he made his home.

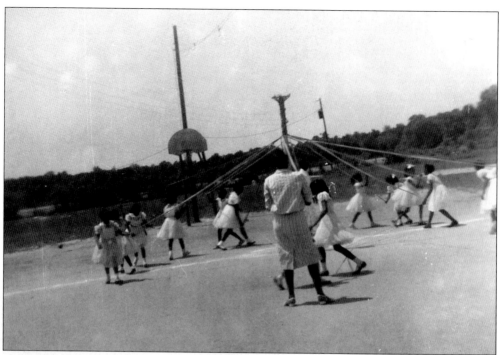

The plating of the Maypole was a tradition at the Chiefland Junior High. The school is no longer there, but no one will ever forget it. The school was burned after integration in 1967.

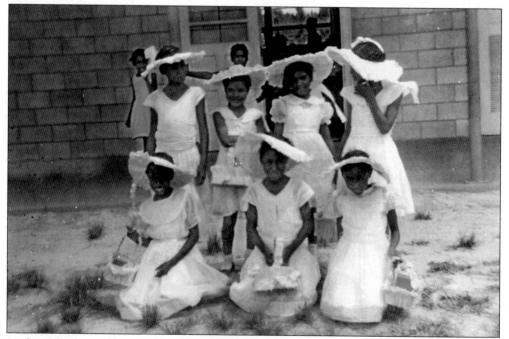

Little girls dress in hats, beautiful dresses, and their baskets. They are participating in *Hear Comes the Easter Parade*. Everyone loved the play, so it was performed more than once.

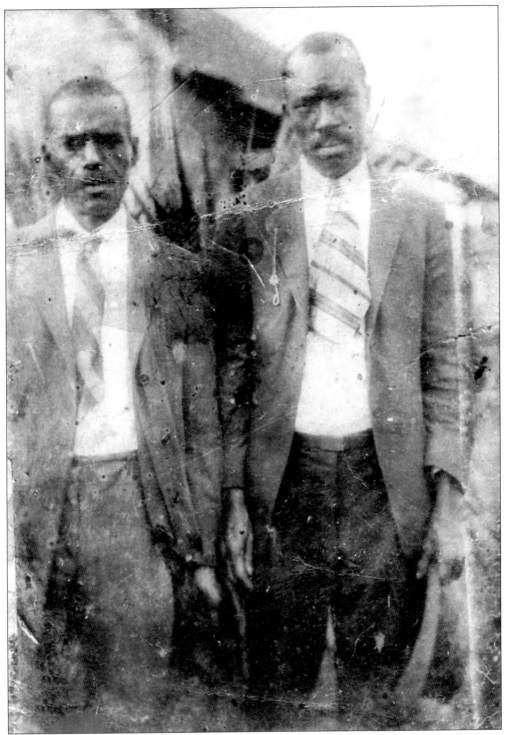

This photograph was taken in 1858. The Jones men are dressed in their Sunday best. Mr. Jones was the father of Margaret Gibbs, who was born in 1900. The Joneses were sharecroppers, and they made a good living.

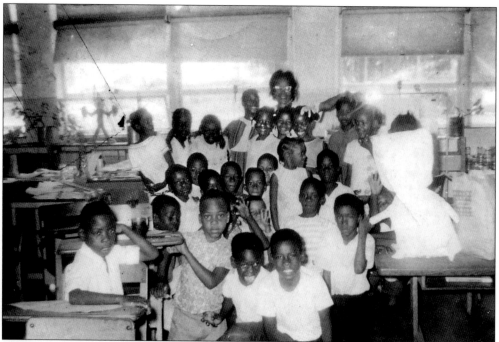

Children inside the classroom are huddled around for their lessons. After a little fun, it is time to learn. Reading, writing, and arithmetic were the main subjects.

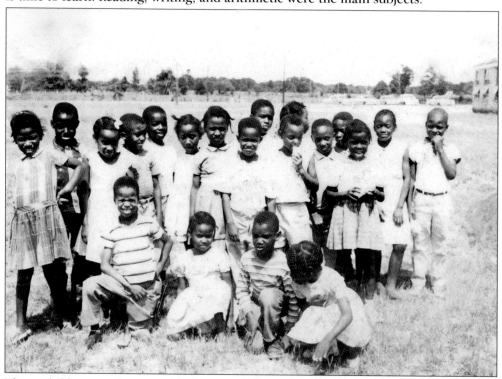

These children work, run, and play, in a field. It was always fun to go outside. There was no gymnasium, only an asphalt basketball court.

110

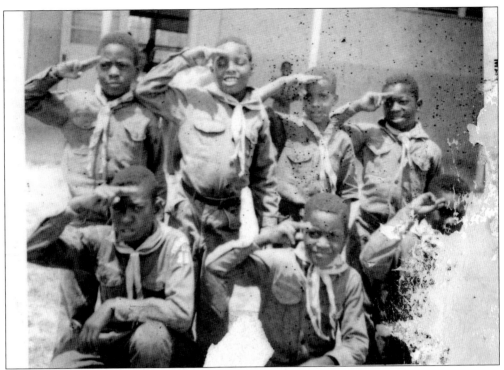

Here are the very brave and honorable Boy Scouts. Being in the Boy Scouts was a great way to learn about the outdoors and about becoming men.

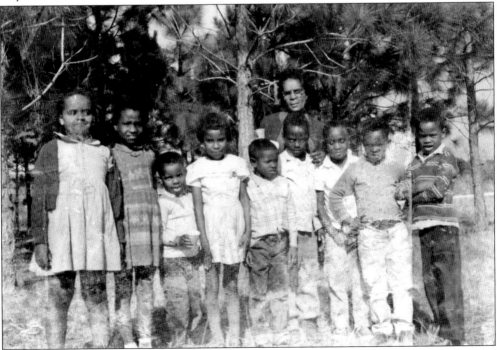

These children have discovered the meaning of expression—just take a good look at their faces. Being outside was always considered one of the best things about school.

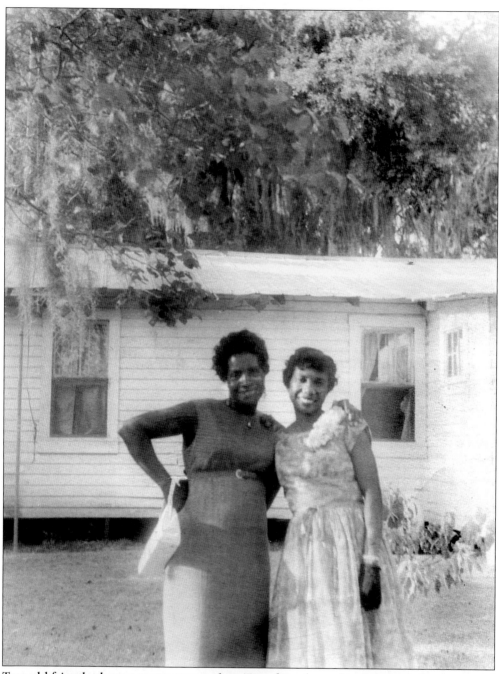

Two old friends share a moment together. True friends are hard to come by, so special moments are captured for reflection in years to come.

Photographed at age 16, Carolyn Hill Cohens had a dream of becoming an artist when she was about eight years old. Mr. Edward Nelson inspired her to go after her dreams. As an artist, Carolyn's mission is to motivate and inspire others through art.

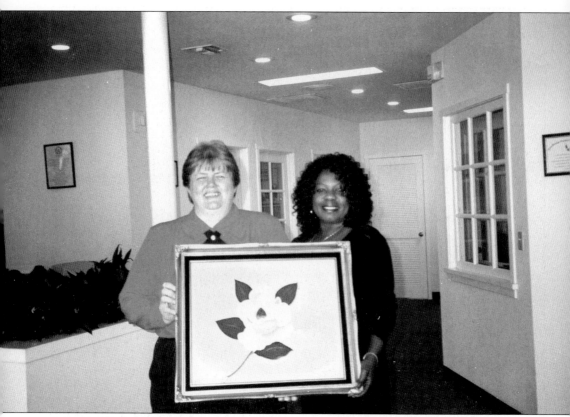

Artist Carolyn Cohens (right) donates a painting to the Essence Women's Club for a contest won by Ilene Polo at Sun State Credit Union. The funds went to a deserving student for college education. This goes to show that dreams can come true.

Mrs. Caretha Nelson is a retired schoolteacher in Levy County. She has done a lot of outstanding things for the community. She was a graduate of Florida A&M University, where she majored in education. She is still very active and involved in many organizations in Levy County.

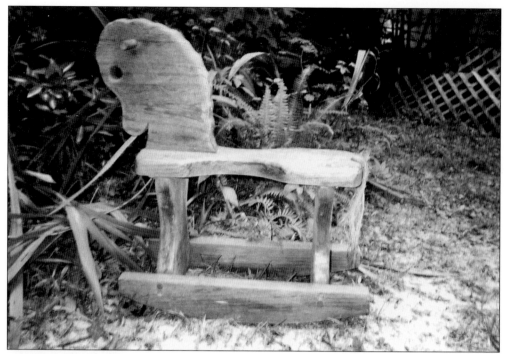

Here are two great examples of creative things that can be added to a yard. Featured above is a hand-carved rocking horse, and below is a bathtub being used as a flowerpot. Many old things are hard to part with, so they are kept them as reminders of old times.

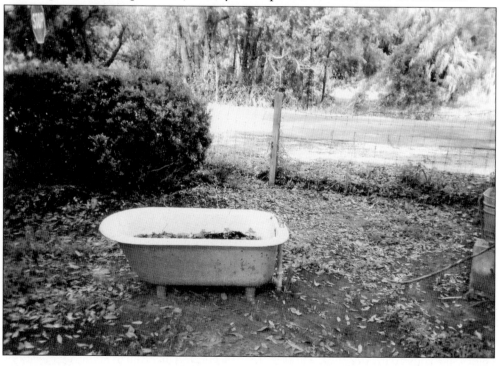

Six

IN MEMORY OF

Marblee Seabrooks was a principal at Chiefland Junior High. His home was in Bartow, Florida. Mr. Seabrooks was always very helpful and easy to get along with. All the students looked up to him.

Mr. Al Dockery was a teacher at Chiefland Junior High. His home was in Chiefland. He graduated from Bethune-Cookman College in Daytona Beach, Florida. His dream was to teach in his hometown, and this he did.

Bertha Monroe was a wonderful teacher, but all the kids knew of her paddle, called Kilroy. She was a strong believer in discipline. As a child, she was crowned Ms. Fort White. She was not only beautiful, she was also very kind.

Euria Lee Williams, a young teacher, attended school in Chiefland and graduated from Bethune-Cookman College an all-black college. She returned home and was an elementary-school teacher.

Minnie Wheeler taught physical education; she worked hard to have a winning basketball team. She was very strict, and there was no talking back, or your basketball career was over.

Victoria Dennis taught fourth grade, and she was well known for her disciplinary measures. Her home was in Daytona Beach, but she taught at Chiefland Junior High until she retired.

Mrs. Jones taught seventh grade and physical education. Physical education was a lot of fun, but the exercise also taught discipline. Academics were also very important.

Mrs. Doris Richardson taught fifth and sixth grade at Chiefland Junior High. She made learning fun, but she wasn't happy until all of her students' work was done. She believed that all students could learn.

124

Mrs. Jessie Battles taught first and third grade. She also taught piano lessons at Chiefland Junior High. She did not let a student slip by, because all students were important.

Ms. Lily M. McIntire was a teacher at Chiefland Junior High; she commuted from Dunnellon, Florida. All little girls admired her because of the way she carried herself. She was very pretty, and they wanted to be like her.

Mrs. Floretta Adams was a beautiful wife and mother. She loved children and was always willing to lend a helping hand. Her children have many wonderful stories to tell about their childhood.

ABOUT THE AUTHOR

Carolyn Cohens is a self-taught artist. She is known as a Chiefland artist; she has illustrated the books *Out of the Past a Noble Leader* and *Origination of the Black Man*. She attended Chiefland Junior High and graduated in 1966 from Williston Vocational High School. Ms. Cohens received the community service award from the Chiefland Men's Club. She was also featured on TV20 for making good news. Ms. Cohens has one daughter, Katrina, and one granddaughter, Asia. Her mission is to motivate and inspire others through her art. She is very thankful for the gift that she has been given.

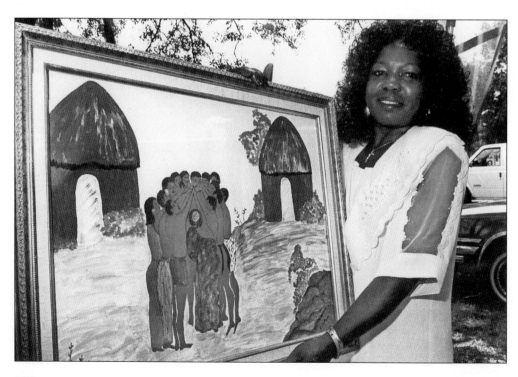